IMAGES
of America

MORGAN HILL

IMAGES
of America
MORGAN HILL

U.R. Sharma
Morgan Hill Historical Society

ARCADIA

Published by Arcadia Publishing
Charleston SC, Chicago IL, Portsmouth NH, San Francisco CA

Printed in Great Britain

Library of Congress Catalog Card Number: 2005920194

For all general information contact Arcadia Publishing at:
Telephone 843-853-2070
Fax 843-853-0044
E-mail sales@arcadiapublishing.com
For customer service and orders:
Toll-Free 1-888-313-2665

Visit us on the internet at http://www.arcadiapublishing.com

ON THE COVER: In 1904, Main Street in Morgan Hill was a dusty track bounded on either side by acres of fruit trees. The trees have now given way to houses, shops, a public library, a school, and a church. El Toro Mountain rises in the background, today as then.

CONTENTS

ACKNOWLEDGMENTS

The majority of photographs in the book are from the collection of the Morgan Hill Historical Society; consequently the book is a kind of portable archive, a museum on the move. The book could not have been created without the loving labor of the Morgan Hill Historical Society, which spent years gathering images to be woven into stories by someone like me. My thanks to everyone who has dedicated their time to preserving the pictures, stories, and history for future generations.

I drew heavily on the archives of the *Morgan Hill Times*, the reference collection at the Morgan Hill Public Library, and the files of the Morgan Hill Historical Society. Unabashed gratitude goes to local historian, Beth Wyman, for her lucid, entertaining, and scholarly book, *Hiram Morgan Hill*, her master's dissertation, and her many newspaper articles. Any and all errors are mine. Thanks also to Marjorie Pierce's book, *The Martin Murphy Family Saga*, which recreates the Murphy family's journey from County Wexford, Ireland, to the Santa Clara Valley. Thanks to Brad Jones who first told me about the persistent pioneering intelligence and family strength of the Murphys. Brad's wife and business partner, Cinda Meister, loves books, and she saw this one coming before I did. Cinda, thank you for your gorgeous imagination and for believing. Anita Kell Mason's book, *Through These Eyes*, gave new context and meaning to every old photograph. Thank you, Anita. All these books are still in print and highly recommended for anyone who wants to delve deeper. The founders' files were another rich vein of information. Thanks to Norma Edes Link for generously sharing the Edes family heritage, without which no history of Morgan Hill would be complete. To everyone who shared their stories and their pictures, I am deeply grateful.

Special thanks to Gloria Pariseau, for encouraging me to create a digital archive for the Morgan Hill Historical Society and to Ellie Weston, John Ward, and Bud O'Hare who graciously helped in finding information fast. Thanks also to my editor, Hannah Clayborn of Arcadia Publishing, for her attention to detail and her guidance throughout. Claudia Salewske, the author of another Arcadia Publishing Images of America title, *Gilroy*, was an inspiration and a practical help in getting me off the ground.

Every author can use a cheerleader, and I have been blessed with several teams worth. Thanks to Kathy Castro and her amazing horse, Santana; to John Lavin, Skyler Madison, Leslie Malin, Pam Rubinoff, and Sonya Stevens, all cheerleaders extraordinaire. My gratitude goes to Babs Moley, who models serenity in action; to good friend and inspiration Kalpana Reddy, to Gretchen Gruner, Rabihah Mateen, Barb Crist, and Mary Ann Finch—gypsy gang, you are my home away from home. Thank you, to my whole grace team and my dear Arzu Calis. I am thankful for Cindy, Sue, Anne, Margaret, and Alice, newfound friends who let me be who I am, but called to tell me they missed me when I was writing. It kept me going. My heartfelt gratitude goes to Vijay, for wisdom and commitment. Thanks also to Gail Straub, for grace and community.

This one is for my father, Harmesh, for sharing his gift of history, and for my mother, Kanta and her gift of story.

INTRODUCTION

A well-known painting by the renowned "painter of light," Thomas Kinkade, portrays Morgan Hill's main street, Americana at its twinkling best. Imagine a general store, lazy sidewalks, small shops with gleaming windows, the inviting prosperity of a tree-lined avenue lit by Old World lampposts. What we don't see—unless we probe deeper into the historic landscape of Morgan Hill—is the valiant pioneer spirit that shaped today's city of Morgan Hill.

A prominent feature of the city's landscape is a mountain peak that rises like a challenge into the skyline. Sooner or later, one gets the urge to climb it. For those ready to give in to the urge and go up the mountain, the Morgan Hill Historical Society leads a hike to the top every April. The mountain is known today as El Toro, Spanish for the bull.

In the 1700s, Spain sent explorers to map the San Francisco region. Franciscan padres were intent on converting the Indians and establishing missions. One of their legacies is the El Camino Real, a 700 mile-long road connecting the missions. Monterey Road in downtown Morgan Hill is a portion of that road. The first written reference to what we now call Morgan Hill is a reference to a "valley covered with many oaks," found in a diary from this period.

The Spanish diarists are also the source of our descriptions of the Ohlone Indians. The Indians left no written records, but archaeological evidence suggests they lived in the area for thousands of years. Local historian Beth Wyman has rightly called them "perhaps our first true conservationists, living in relative harmony with nature." They left no permanent buildings or highways, few marks on the environment. The visual record of the Indian era is written in rock art, burial sites, and sandstone mortar holes, rather than photographs. You could say their legacy is clean air and water, thick forests, and wildlife.

Some locals still call the mountain Murphy's Peak, after the Murphy family, the first pioneers to settle our area in 1845. The Murphys were also the first to bring wagons and cattle over the Sierra Nevada, defying the steep precipice of rock with an ingenious system of pulleys and winches. They opened up the California trail for many others who followed in subsequent years, including the Donner Party. Notorious Donner Pass was first named Truckee Pass by the Murphys. The same mountain pass became the route for the transcontinental railroad connecting the West Coast with the rest of the nation. The railroad made it possible for California farmers to ship fruit and vegetables out of their fertile valleys, and for developing towns throughout America to receive California's abundance.

The Murphys' journey West lasted many months, crossing rivers, a desert, and snowy peaks. Men, women, and children took turns traveling on foot. Two of the women were pregnant and gave birth along the way.

In 1846, Martin Murphy Sr. paid $1500 for the 9,000-acre Rancho de Ojo de Agua de la Coche (Pig Springs Ranch) including the area that today is Morgan Hill. Its previous owner, Mexican citizen Don Juan Maria Hernandez, had built an adobe home near where Hale Avenue and Llagas Road are today. Unfortunately, the property was bulldozed so we have no material record.

The images in this book are snapshots, fleeting windows through which we can begin to glimpse our town's history. Inevitably, history keeps secrets. In these instances, we are free to form our own stories, connecting images with facts—at least until history reveals her hand.

We know that Hiram Morgan Hill married Martin Murphy Sr.'s granddaughter, Diana, heiress to thousands of Murphy acres. Morgan Hill and Diana parted, but their fragmenting marriage opened up the land for settlers. Images in the collection show ranchers working the land and conservationists doing their best to preserve it. Homes and schools were built. The presence of the Southern Pacific Railroad through fertile land spurred the growth of local agriculture, making it easier to transport bulk produce out to markets on the populous East Coast and points north and south. A growing economy yielded inevitably to small town development. Through all the changes, one aspect of the skyline has remained solid and constant. The rising peak of El Toro imbues our small city with a sense of indomitable spirit, a place where history's challenges are met over time.

May we be inspired by the courageous spirits of the pioneers who first built homes here, the persistence and foresight of Martin Murphy Sr., the creativity of Charles Kellogg, and the caring of Sada Coe. And may we rise to the heights of community, cherishing ourselves, our neighbors, and our hometown.

One
A ROMANTIC
CONQUEST

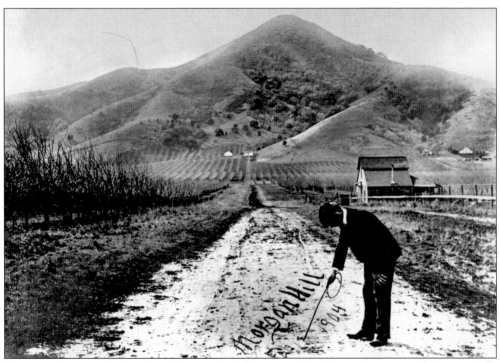

The prominent peak rising into the town's skyline over Main Street is not named Morgan Hill. Morgan Hill was a charming southern gentleman from Missouri who came west seeking his fortune and a new life. In those days, the hill was called Murphy's Peak, after the Murphy family who controlled thousands of acres in every direction. Morgan Hill secretly married the beautiful Diana Murphy, heiress to many of those acres.

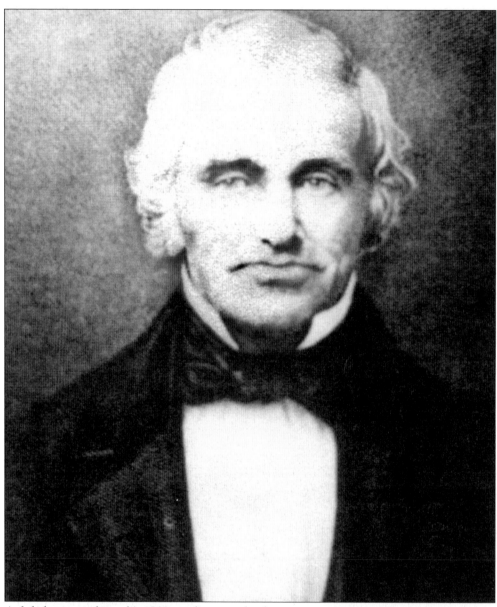

A faded portrait from the 1800s understates the fiery vision of Martin Murphy Sr., a strong-minded patriarch from County Wexford, Ireland. In 1844, Murphy was intent on finding a practical route from Iowa to California. He moved his large family: sons—married and unmarried—daughters, and grandchildren. His wife had died of malaria in Iowa. A Jesuit missionary told him about the healthy California climate and the Franciscan missions, a place good for body and soul. The most direct route through the steep mountains of the Sierra Nevada was deemed impossible for wagons. Murphy Sr. and his family voted to do it and planned to succeed. When they came to a sheer rock face that blocked their path, the Murphys unhitched the oxen and led them through a narrow rift, single file. Then the oxen hauled the wagons over the vertical rock with an ingenious system of pulleys. In subsequent years, other settlers from around the world followed the same trail, including the Donner Party. The mountain pass eventually became the route for the transcontinental railroad and Highway 80.

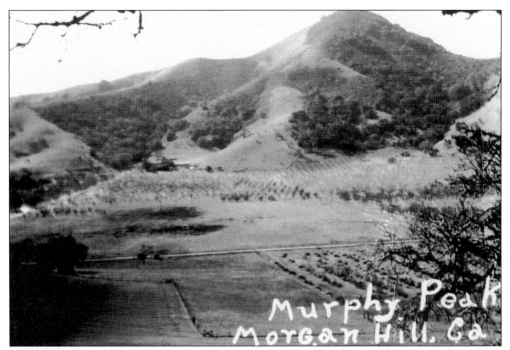

Murphy Peak Morgan Hill, Ca

In 1846, Martin Murphy Sr. purchased 9,000 acres known as the Rancho Ojo de Agua de la Coche, or Pig Springs Ranch, in the region of today's Morgan Hill. The ranch spanned the valley and rose into the hills on both sides. Murphy Sr. would sometimes ride to the top of the mountain, looming over 1,400 feet above the valley. It provided an excellent vantage point to survey grazing cattle and the general lay of the land. A New York reporter who rode with him one day described the mountain, "rising like an island in the sea of air." Long after Murphy's death in 1865, this 1930s postcard still referred to the mountain as "Murphy's Peak."

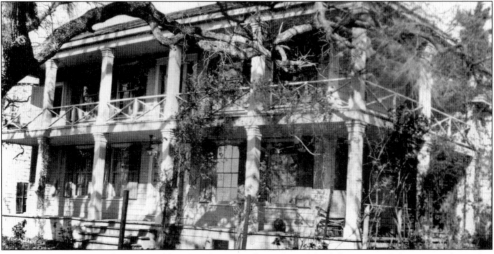

At first, Martin Murphy Sr. and his family moved into an old adobe, part of the original rancho property. As recorded, it was northwest of the Hale-Llagas Road intersection and has long since been demolished. Then he moved with his family to this new home, built of redwood planed by the family's steam-powered lumber mill. The house was built near the intersection of San Martin and New Avenues.

11

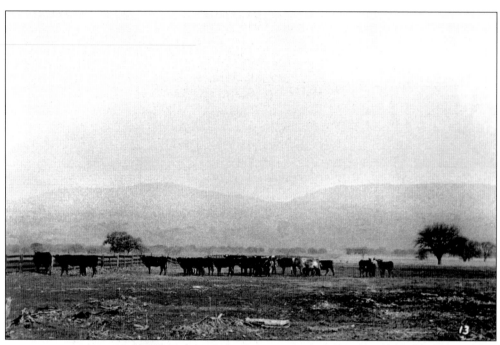

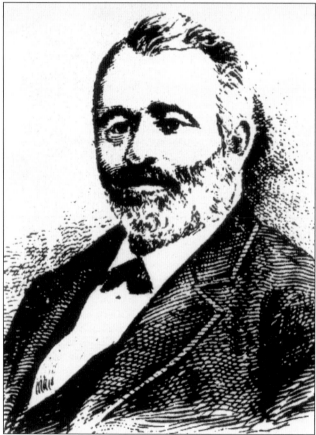

By 1876, the Murphy family owned most of the area that is now North Gilroy, Uvas, San Martin, Morgan Hill, Madrone, and Coyote—more than 70,000 acres. Martin Murphy Sr.'s youngest son, Daniel, had made the trek to California with the family on the first wagon train. In 1851, he married Mary Fisher, the land heiress next door, and acquired a large portion of the neighboring 19,000-acre Rancho de Laguna Seca with the alliance. Daniel invested in land and cattle, and when he died, in 1882, the newspapers reported that he owned more land and cattle than anyone in the country. His holdings included a four million-acre ranch in Durango, Mexico. It is more significant locally that his son and daughter each inherited half of the Ojo de Agua de La Coche, the ranch that Martin Murphy Sr. originally purchased.

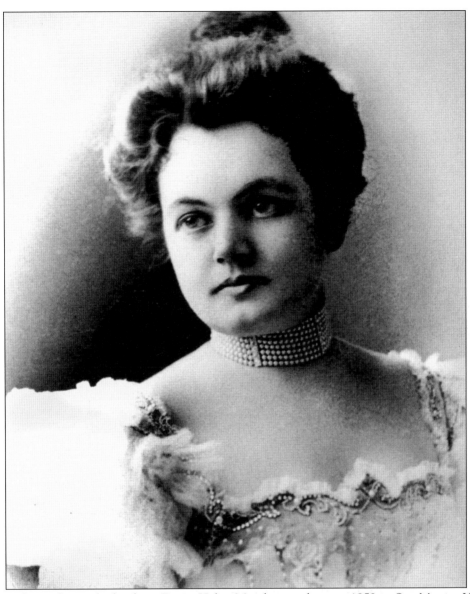

Daniel Murphy's only daughter, Diana Helen Murphy, was born in 1859 in San Martin. Her father affectionately called her "Dannie." Famous for her regal beauty and known for her "eyes like violets," she rebelled against provincial life, claiming she was descended from Irish kings, and demanded that everyone except her father must call her "De-awhn." Society knew her as the "Duchess of Durango" because of her father's extensive landholdings in Durango, Texas. She attended Notre Dame College in San Jose. At 22, she met a well-mannered, charming gentleman from Missouri named Hiram Morgan Hill. He was 33, worldly in her eyes. He dressed elegantly and could skillfully drive a fine carriage with matching horses at top speed. Her parents both disapproved of the match. Without telling them, she and Morgan Hill were married in a secret ceremony in San Francisco on July 31, 1882. Two months later, her father, Daniel Murphy, lay dying. On his deathbed, he demanded a promise from her that she would never marry Morgan Hill. Concealing the marriage, she told him what he wanted to hear. After his death, and haunted by her false promise, she sought a divorce.

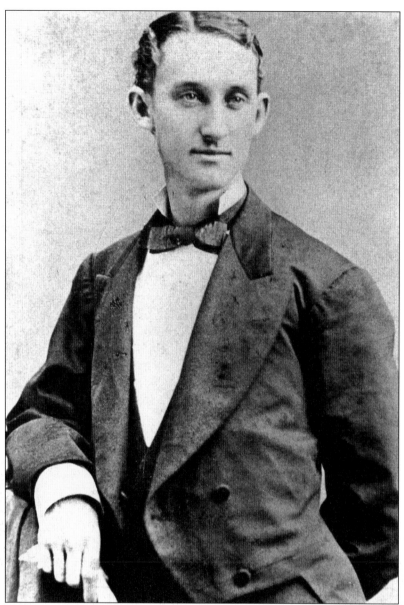

Morgan Hill rarely used the Hiram that was his first name. He arrived in California with his younger sister in the 1870s. Hill was born on March 4, 1848, in Cape Girardeau, Missouri, a river town on the Mississippi. Brother and sister were orphaned at an early age and grew up in their grandparents' home. When Morgan Hill was 22, historians say that he fell in love with his first cousin. His grandmother instructed him to leave town without delay and seek his destiny elsewhere. Arriving in San Francisco, Morgan Hill found employment at a bank, but also modeled clothes at the Palace Hotel. In 1880, when he caught Diana's eye, his appearance was princely. He was tall, slender, blue-eyed, a gracious southerner, elegant in dress and in manner, with a fine buggy and matched team of horses—all suggesting to her that he knew what was truly important in life. He proposed in June 1882, and she accepted. Her parents' disapproval only made it seem more romantic. They must elope and keep the wedding secret. Everything went as planned until her father died.

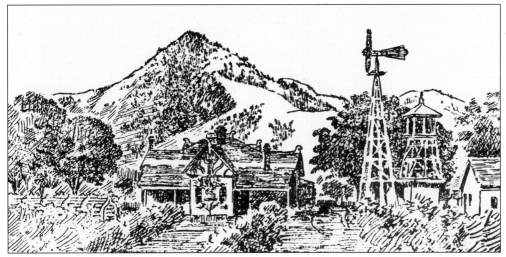

After her father's death, Diana filed for divorce. But before the case could be heard, her friends and family helped to reunite her with Hill. One year after the wedding, the couple finally left for a honeymoon in Europe. When they returned, they built the Villa Mira Monte, named for its view of the mountain. The house is also known as Morgan Hill House. The above sketch was published in the *San Jose Mercury News* in 1892 and reveals the eastern aspect of the house—the rear view as it appeared to visitors arriving by train. The railroad runs directly behind the property. The front of the house is shown below. (Courtesy Gilroy Historical Museum.)

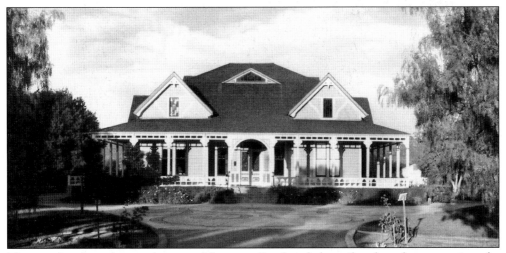

The couple selected a site between Monterey Road and the railroad tracks, convenient for traveling. The home is in the fashionable Queen Anne style, built from sturdy redwood lumber hauled from Watsonville by oxcart. It was finished with elegant details of the period that have been preserved in almost original condition. The house was added to the National Register of Historic Places in 1978 and is located on 17860 Monterey Road.

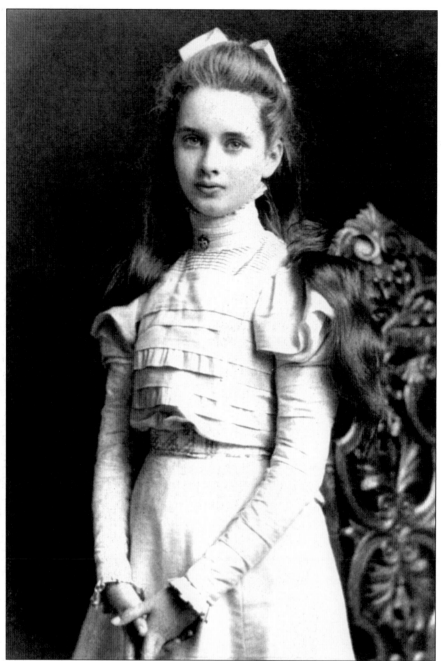

Diane Murphy Hill was the only child of Diana and Morgan Hill. She was born in 1884 at the Villa Mira Monte. Sadly, her life was to end tragically in 1912. Her parents parted while she was still a child. In this portrait, she is 12 years old. Her parents proudly proclaimed her even more beautiful than her mother. She was educated at the best schools and became fluent in French and German—the languages she spoke at home with the European servants. She also conversed in Spanish with her grandmother. Her mother held high social ambitions for Diane's marriage. She was intent on introducing her daughter to the finest European aristocracy. Young Diane said that she would rather marry "an honest farmer."

In 1902, Diane made her debut into Washington, D.C. society. By this time, her mother and father were living separate lives. Her father, Morgan Hill, focused on raising cattle at the ranch in Nevada and her mother, Diana, was a busy socialite in the nation's capital. At the time of this photograph, Diane was about 18 and living with her mother in the city. In 1911, she married the Baron H. de Reinach-Werth at St. Matthews Cathedral in Washington. Local newspapers reported that her mother and father were the only witnesses. The couple honeymooned in Europe. The marriage came to a sudden and tragic end a few months later in 1912. In Paris, she received news that her father Morgan Hill had suffered a stroke. She herself suffered a nervous breakdown and was hospitalized at St. Pancras sanitarium in London. Her death certificate states that she threw herself from a high balcony window onto cobblestones below. She was instantly killed from a massive skull fracture and compression of the brain. Morgan Hill died the following year in 1913, in Elko, Nevada.

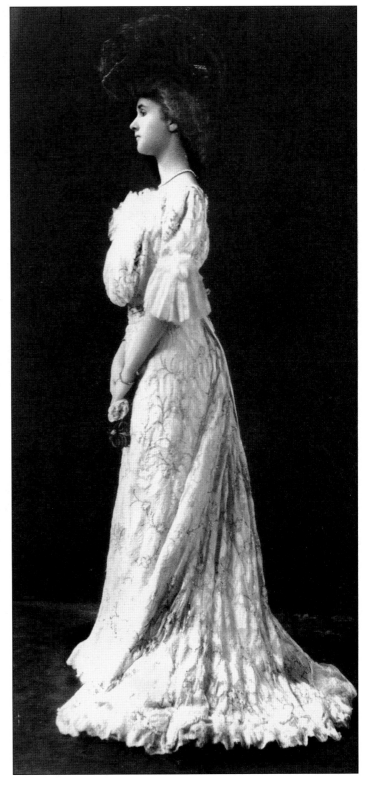

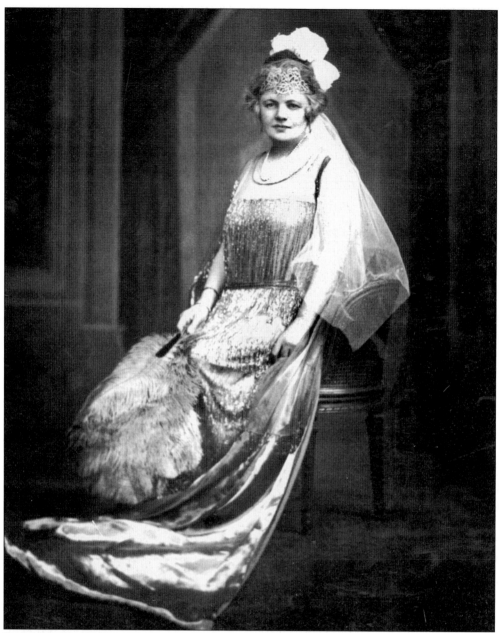

Diana Murphy Hill was in her fifties when Morgan Hill died. After his death, she lived in Nevada for a time, but in 1919, she emigrated to live in England. Three years later she married a knight of the realm, Sir George Rhodes. In 1922, at the age of 63, Diana was presented in court to King George V of England, as Lady Diana Helen Murphy Hill Rhodes. She is shown here in her court dress. Sir George's cousin was Cecil Rhodes, for whom the country of Rhodesia was named, but perhaps remembered best today for his legacy of the Rhodes Scholarship. Unfortunately, Diana's marriage to Sir George was all too brief. She was widowed in 1924 when he died at their villa on the Riviera. In some ways, Diana was indomitable. She lived to be 78. In 1937, she contracted tuberculosis and died in Cannes, France, a week before Christmas.

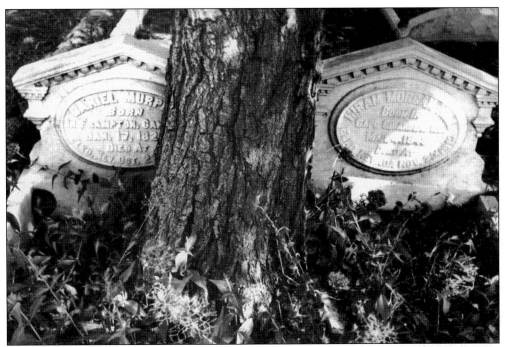

Diana's father, Daniel Murphy, and her first husband, Morgan Hill, are buried side by side at Santa Clara Catholic Cemetery. (Courtesy Joyce Hunter.)

A detail from the front door of the Villa Mira Monte reveals Morgan Hill's initials deeply carved into the design. The house has been carefully preserved by the community. Despite earthquake damage, it has undergone restoration and is now close to its original condition. In 1978, it was added to the National Registry of Historic Places. Located on 17860 Monterey Road, the house is one of the treasures of Morgan Hill's history and is open to the public.

19

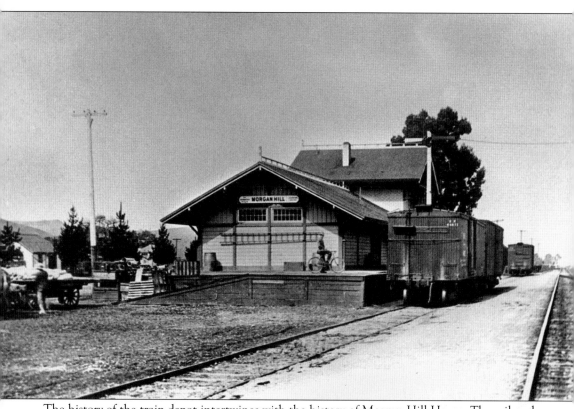

The history of the train depot intertwines with the history of Morgan Hill House. The railroad tracks passed directly behind the house, a significant landmark. Travelers would ask to be dropped off at "Morgan Hill's." Although the Southern Pacific Railroad listed the stop as "Huntington," through popular usage the stop became known as "Morganhill," and finally as the Morgan Hill Station of the Southern Pacific Railroad. The ranch property was divided into lots and sold to settlers. In 1892, the next phase of Morgan Hill's community development began.

Two
1892–1906

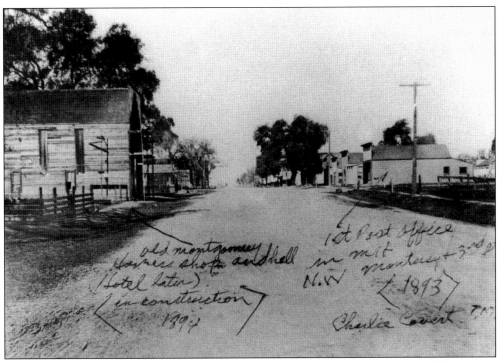

In 1893, Monterey Road was one of the most traveled north-south arteries in California, part of the old El Camino Real and a central traffic artery through the Morgan Hill ranch. This photo, one of the oldest showing settlement along the road, shows Charlie Covert's building, the Cozy Corner Saloon, at 17300 Monterey. Covert was also an agent for the Sunset Telephone Company and Morgan Hill's first postmaster.

On July 25, 1896, someone photographed four different aspects of the growing village. This view of El Toro Mountain, also known as Murphy's Peak, is seen from Monterey Road. It fits well with the description recorded in an 1892 edition of the *San Jose Mercury News* of "long stretches of level plains, heavily wooded, with ancient oaks giving the appearance of an English park."

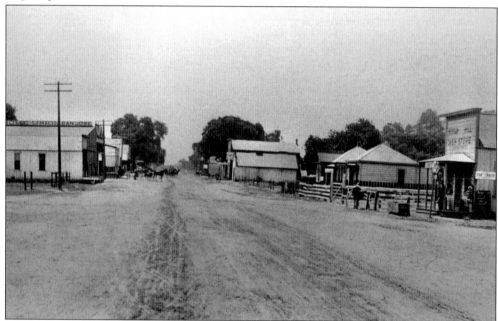

This second view is from the corner of Main Street and Monterey Road. By 1896, the village had about 250 inhabitants and many of the essentials—"a train depot, post office, telephone station, express office, two hotels, a restaurant, three stores, a livery stable, lumber yard, and several small shops, with a number of very comfortable residences." Some predicted it would become the principal town between San Jose and Gilroy.

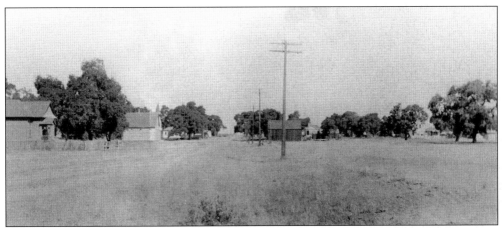

A panoramic view of Monterey Road, looking north, as seen on July 25, 1896, shows few buildings. On the left is the United Methodist Church, located on the corner of Monterey Road and Fourth Street, still a downtown landmark today. When it was built, the town's first church was shared by more than one denomination and was also used as a community school and gathering place.

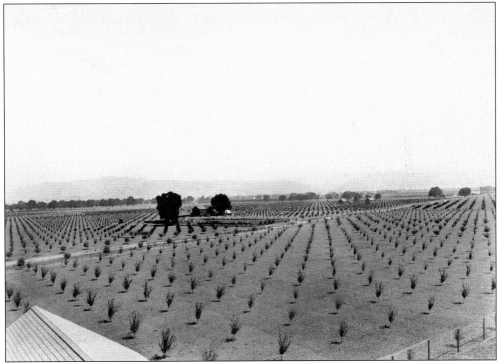

The last of the images from July 25, 1896, reveals the eastern aspect of the valley from the vantage point of Diana Avenue. A few oak trees survived to provide much needed shade, but most were cut down for lumber and cash. The cleared land was planted with prune trees. Fruit orchards eventually replaced many of the large wheat fields and cattle ranches throughout Santa Clara County.

Idyllic walks and picnic areas could be found in every direction. An easy 10-minute horse ride
south on dusty Monterey Road would bring you to this cool and refreshing spot. Ancient trees
afford beauty and shade beside Llagas Creek near the railroad bridge in San Martin, c. 1899.

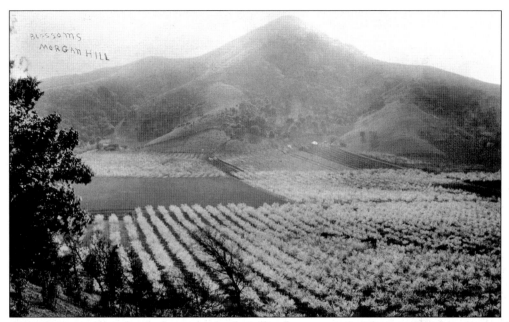

An early postcard, undated, shows the fertile valley floor covered with row upon row of prune and other fruit trees in bloom. By the early 1900s, many of the old "valley oaks" had been cleared. Today, most locals call the mountain by its earlier Spanish name, El Toro. The elevation of the mountain is over 1,400 feet. The image below shows a view of the growing village of Morgan Hill from part way up the northwest arm of the mountain. From the buildings, we can date this view to between 1894 and 1905. On the horizon, is the eastern range of mountains, the Diablo Range. The distance directly across the valley floor from the eastern foothills to El Toro Mountain is less than five miles.

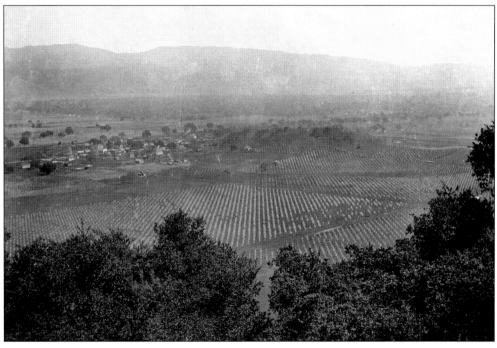

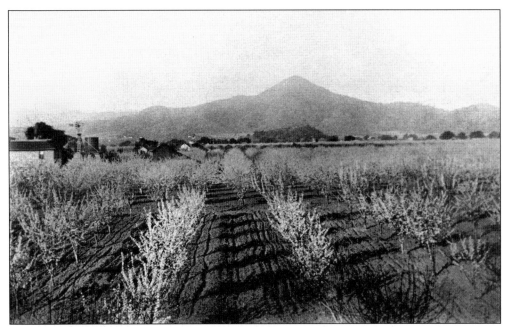

The Morgan Hill ranch comprised more than 10,000 acres when it was subdivided and sold by the C.H. Phillips Land Company, a highly regarded California developer. Lots were sold for $100 per acre. Four streets were included in the first town plat: Main Street, Diana Avenue, Dunne Avenue, and Hill Road. The Hatch family bought a lot and built a home on Dunne Avenue, c. 1900.

Early Spanish explorers and missionaries recorded the thick oak forests and groves of the valley in their reports and diaries. In 1892, this view of Morgan Hill's oak trees was part of a promotional flier that was sent to George A. Edes's printing office in Watertown, South Dakota. Drawn to the developing community, Edes left his business and newspaper in South Dakota, and brought his skills to Morgan Hill.

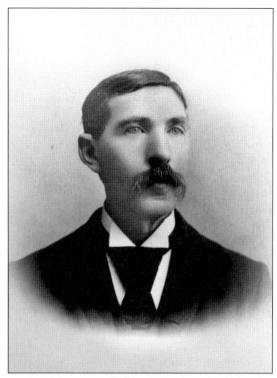

In 1894, Edes published the first issue of the *Morgan Hill Sun*, the forerunner of today's *Morgan Hill Times*. The *Morgan Hill Times* is the oldest continuous business in Morgan Hill. Edes came from a long line of printers dating to Revolutionary times. His grandfather, Benjamin Edes, operated a printing office in Boston. It was from his office that the Sons of Liberty dressed as Indians before the Boston Tea Party. In 1896, Edes built a house on the corner of First Street and Del Monte Avenue (shown below). It has now been owned by the Edes family for three generations.

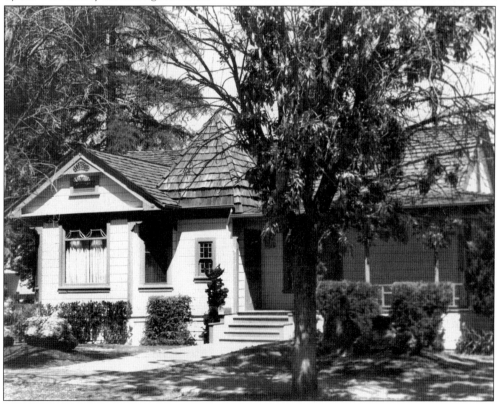

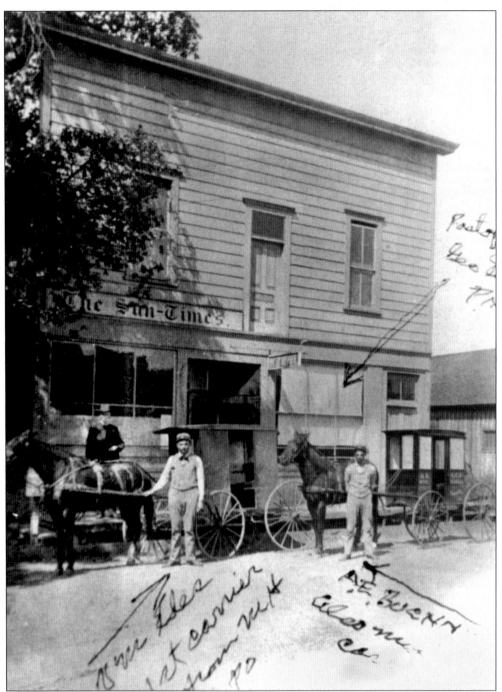

In 1897, Edes was appointed postmaster of Morgan Hill. For convenience, the post office operated in the same building as the newspaper. Vertie Edes, one of George's sons, was the first rural mail carrier. By 1901, Edes's responsibilities as postmaster had grown and he sold the *Sun* to George Lynch. The newspaper became *The Sun-Times* under the ownership of Rev. H.H. Farnham in the same year. In 1906, owners Heimgarten and Noll changed the name to the *Morgan Hill Times*.

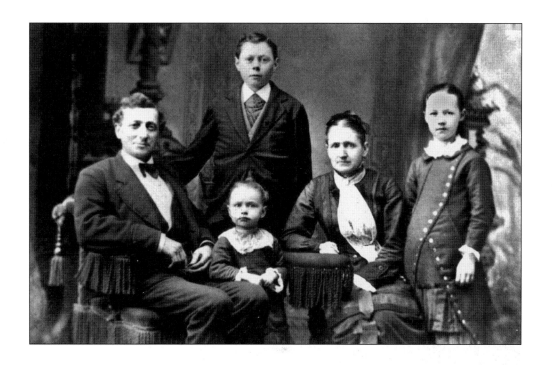

James P. Ward and Ora Ward came to Morgan Hill in 1894. This family portrait dates from an earlier time. The children are Wilbur, Gertrude, and Grace. Ward was born in Ohio in 1834. He farmed in Wisconsin for 14 years, later becoming involved in farming and politics in South Dakota. He and his son Wilbur were visiting old friend, George Edes, when Ward, recognizing the beauty of the valley, proclaimed it "Paradise." The view below shows Paradise Valley c. 1899.

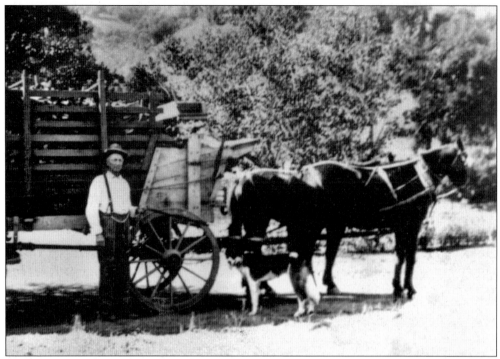

Ward purchased 75 acres of wooded land at $100 per acre in an area still known today as Paradise Valley in Morgan Hill. The land was part of the Catherine Murphy Dunne estate. Before building a home for his family, he cleared 30 acres of trees, making three trips a week to San Jose to sell lumber. Generally, settlers paid their first mortgage payments with cash from lumber.

In 1890, Ward built a three-story farm house for his family. More than 100 years later, the house is occupied by the fourth generation. Paul and his wife, Anne Ward, have retained much of the original flavor of the house, surrounding themselves with the original furniture that came from South Dakota. The land has supported poultry farming and yielded peaches, prunes, and walnuts.

30

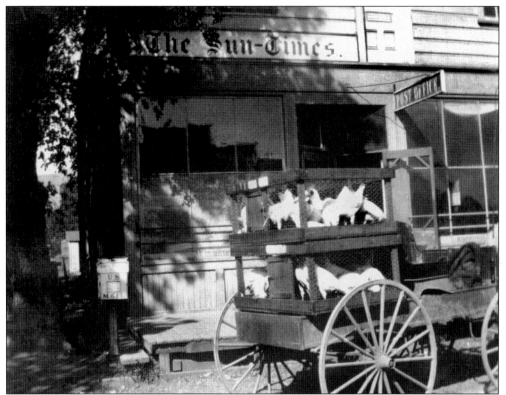

The Wards' farm wagon is parked outside the post office and *Morgan Hill Sun-Times* building. Perhaps J.P. was visiting his old friend George, picking up mail and discussing the news of the day. During its first 39 years, the newspaper operated in several locations, including Monterey and Second Streets. For the past 71 years, it has been at the current location on East Third Street. (Courtesy John Ward.)

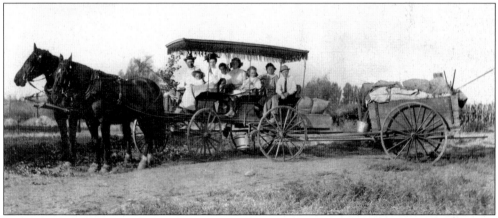

In the early 1900s, long before minivans and station wagons, Wilbur Ward and his family loaded up their wagon and trailer and set off on a pleasure trip to visit friends in Turlock. Journeys like this lasted a couple of days. There were no Gameboys or portable CD players, but their ample supplies included equipment for camping outdoors under the stars and for cooking along the way. (Courtesy John Ward.)

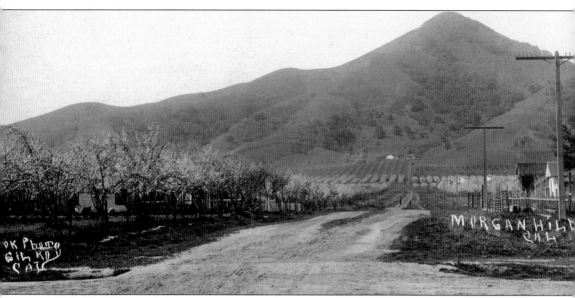

A turn-of-the-century postcard view of El Toro Mountain and Main Street is thickly planted with fruit trees. Main Street was a dusty, dirt road. Nowadays, the Morgan Hill Historical Society sponsors a hike to the top of El Toro Mountain once a year in April. Before the hike, local geologist Peter Anderson gives a talk about how the mountain got its shape. It is not a volcano. Between 65 and 100 million years ago, when the entire valley was covered by water, the landmass now known as El Toro was located in the Pacific Ocean. A few degrees south of the equator, Anderson says. Magma flowed out of a long fissure in the ocean bed and cooled almost immediately. El Toro is part of that cooled lump of ancient rock. It was transported 5,000 to 7,000 miles eastward over millions of years to where it is today. The conical peak is a testament to the hard resilience of the rock, which has withstood years of erosion. Myths abound about how the mountain got its name. Some say that the peak resembles the hump of a reclining bull, so it was called El Toro until the Murphys bought the land, when it became Murphy's Peak. Both names are apt.

The city of Morgan Hill has its own "official" rock. The Natural History Museum of the Smithsonian Institution in Washington, D.C., has classified "poppy jasper" as a semi-precious gemstone that is unique to Morgan Hill. Jasper is a very common quartz-type mineral found throughout the southwest but Orbicular Jasper, the scientific name for the type found on El Toro, is rare. This 10-inch, cuboid chunk of red and yellow poppies is on display at the community center at the corner of Dunne Avenue and Monterey Road.

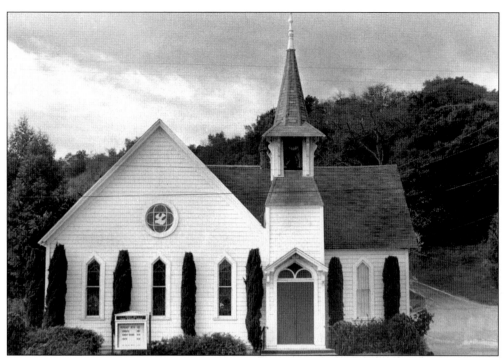

The first church in Morgan Hill was built in 1893 as a Methodist-Episcopal church. As a gesture of goodwill, the town developer, C.H. Phillips Land Company, donated a gift of three building lots and $50 to the community, specifically for the church. Lumber was hauled by wagon from San Jose. Volunteers erected the structure, providing all the labor. Church records report that both congregations united in worship with alternating ministers. One minister would preach here, the other traveled to nearby Coyote and led services there. The building also served as a school. When the new school was built, the students took their chairs with them. The church bought new chairs and eventually pews, in 1898. The church is located at 17575 Monterey Road, on the corner of Fourth Street.

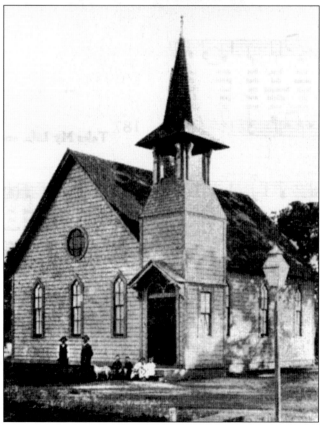

Charles and Catherine Stone had been married only 10 years when they arrived in Morgan Hill in November 1893. They became the sixth and seventh members of the Methodist-Episcopal church. The first five were Mr. and Mrs. Woodard, Nellie Woodard, Miss Lottie Stephens, and Henry Tozier. Funds were needed to finish the church's interior. Records state that one of their fundraising strategies was to send Mrs. Stone to the post office on the day that gentlemen called for their mail. She was to ask for a donation for the new church. Since she didn't know their names, she arranged for the postmistress to call the men's names aloud as she handed them their mail. Then Mrs. Stone would bid the gentleman hello by name, and ask him for a donation. In this way, she raised $20—quite a lot of money for those days. Mrs. Stone was first president of the Ladies Aid Society. In 1894, the society raised $85 to buy the church bell. Seen below is an image from the early 1900s of Charles Stone and his son Fred hauling packed prunes to the depot.

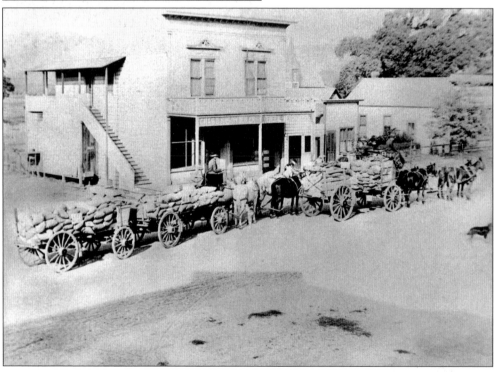

Catherine Murphy Dunne was born in Wexford, Ireland, in 1828. Her parents, John and Mary O' Toole, immigrated to Canada when she was two years old and she grew up within an Irish-French-Canadian community in Quebec. In 1851, she married Bernard Murphy. His father, Martin Murphy Sr., had left Canada in 1844 to found a community in California. Bernard, now happily married, followed with his bride. Sadly, Catherine was widowed in 1853 when Bernard died aboard the steamer *Jenny Lind* following a boiler explosion that killed many on board while it was crossing San Francisco Bay. Some years later, in 1862, Catherine married James Dunne. Her estate was subdivided and sold to settlers.

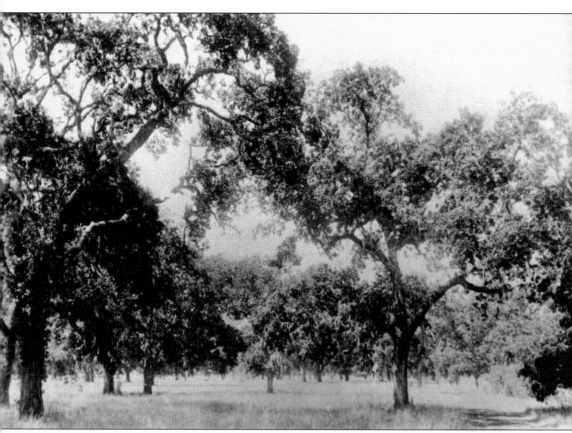

Dunne Woods was part of the Catherine Dunne Ranch, shown here in the early 1900s, where San Pedro Avenue and Barrett Road are today. This photograph is a portion of a sales brochure for the subdivision of Catherine Dunne's property. The oak groves were a proven incentive to attract settlers. Though it was hard work to clear the trees, and accidental injuries could occur when the stumps had to be blasted with dynamite to get them out of the ground, sale of the wood could offset the first few mortgage payments.

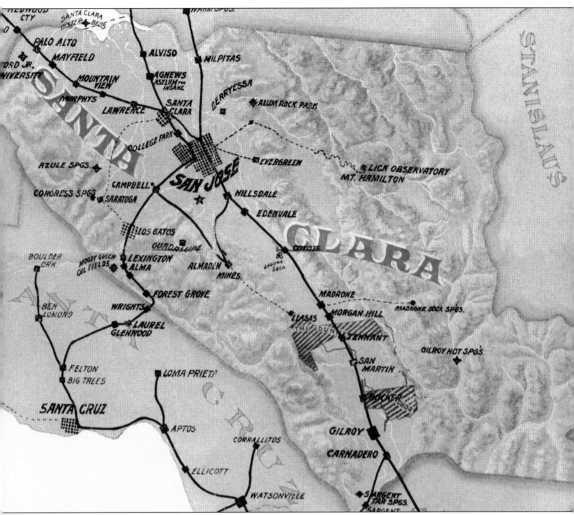

A map of Santa Clara County was included in the sales brochure for Catherine Dunne's property. The years of the Gold Rush were past, but the fertile valley and mild climate continued to draw settlers. Many farms and small towns sprang up throughout the valley. The Catherine Dunne Ranch adjoined the Morgan Hill Ranch on the south, extending across the valley into the mountains on either side. It was sold as the "last of the Great Murphy Estates."

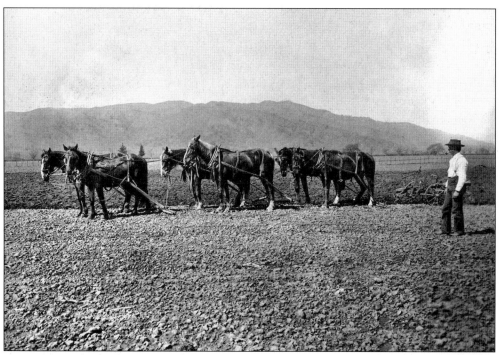

The Lewis family used horses as draft animals on the farm, like many families in the late 19th century. Here, Fred A. Lewis has a team hitched and busy at work.

The Madrone area began as a campsite for cowboys on the Laguna Seca Rancho, which was owned by the Fisher family. The Laguna Seca adjoined the Murphys' Ojo de Agua de la Coche on the north. Madrone was the area north of Cochrane Road and was annexed in 1958. The Pinard Saloon was the center of that community for many years. Madrone Hotel is on the left, c. 1890.

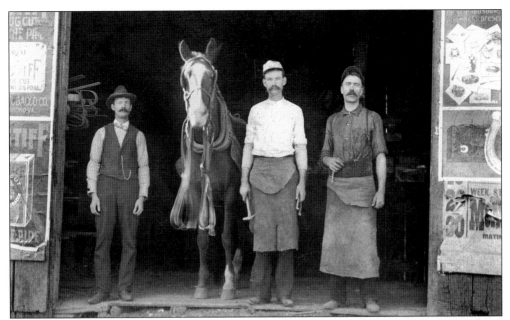

Back then, blacksmiths were as necessary as gas stations are today, particularly in Madrone, where cattle roundups were major community events from 1869, when the railroad came through, until the 1940s. Each year Henry Coe's cattle were driven down Steely Road to the railroad at Madrone. The Morgan Hill police would stop traffic on the two-lane highway so that the cattle could cross over to the corrals along the railroad. Cowboys depended on conveniently located blacksmiths and most folks relied on horses for transport, work, or leisure. The photograph above was taken before 1900, perhaps a year or two before the one shown below, of Thomas Matthieson with a fine looking horse, on the corner of Peebles Avenue and Monterey Road. The Peebles tract was laid out about 1900. The oldest homes on the road today date back to that period.

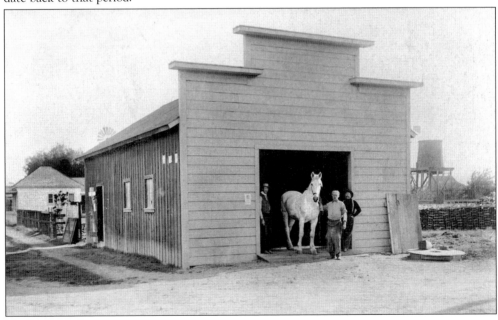

Tom Mathiesson is shoeing a horse at his blacksmith shop, *c.* 1900.

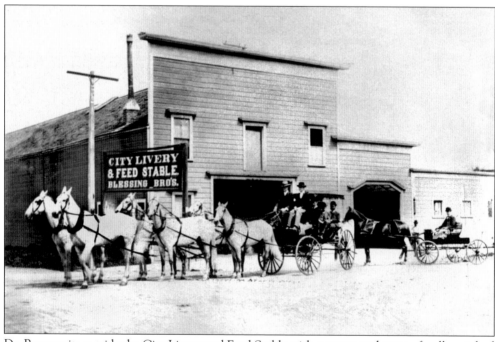

Dr. Banner sits outside the City Livery and Feed Stable with a surrey and team of well-matched horses, ready to make his house calls *c.* 1900.

40

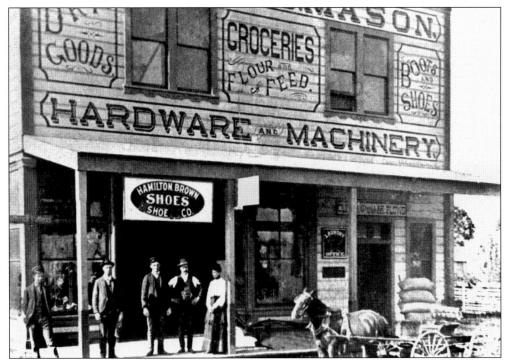

The building at the northwest corner of Monterey Road and Second Street has a long history. At one time, there was a social center and community hall on the second floor and the store downstairs sold just about everything. Today, Anita Kell Mason owns a real estate business in the building. She is no relation to the Charles Mason who owned the structure in 1902, but her great-great-great grandfather was Martin Murphy Sr. His daughter Margaret married Thomas Kell.

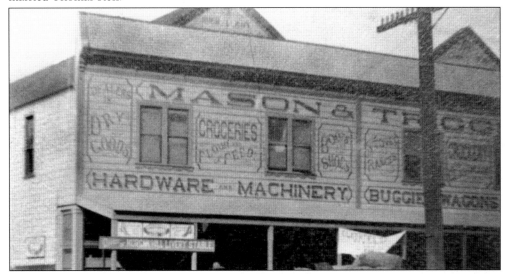

By 1905, a second building had been joined to the first. The tops of two gables can be seen over the front that connects them. Two business partners united under the banner of Mason & Triggs, serving a growing community of about 500 settlers and selling everything from dynamite and handsaws to flour for baking.

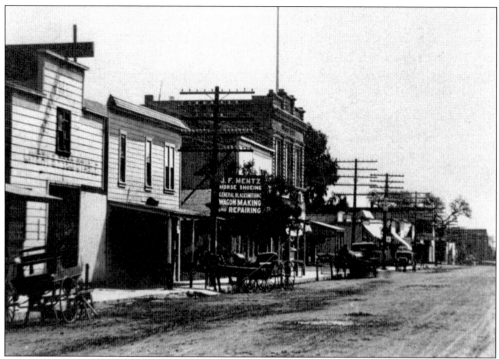

While you were buying flour at Mason & Triggs, your wagon wheels could be repaired across the road, and the horse could be fitted with new shoes. Monterey Road was unpaved dirt, and during the hottest days the dusty road was sprinkled with water to keep the dust from flying. There were plenty of parking spaces for carts and buggies.

By 1896, the southwest corner of Monterey Road and Second Street was also built up. Only four years had passed since Diana and Morgan Hill sold their inherited ranch lands to a developer, but already the building blocks for today's downtown were emerging.

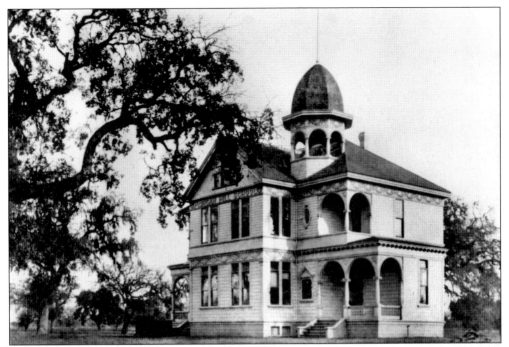

The first Morgan Hill Grammar School was built in the early 1890s. It was considered an architectural wonder for miles around and a strong selling point for the town's developers. The building was torn down in the early 1900s to make way for new construction. The school bell is now part of the Morgan Hill Museum's collection.

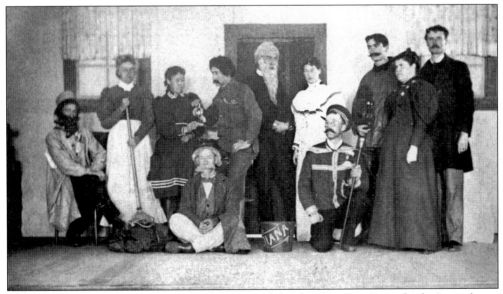

On December 20, 1895, some early settlers enjoyed the dramatic arts. *Down by the Sea*, a drama in two acts, was presented in the upper story of Morgan Hill Grammar School (shown above).In the cast was Miss Worcester—school principal of Morgan Hill Grammar School, Miss Emma Richards—teacher, Dr. J.T. Higgins, A.C. Sterrett, Vertie Edes, Kate Bone, Ed Swope, Rev. Gray—Baptist minister, Jay Jacobs, I.B. Briscoe, and Mrs. Yule.

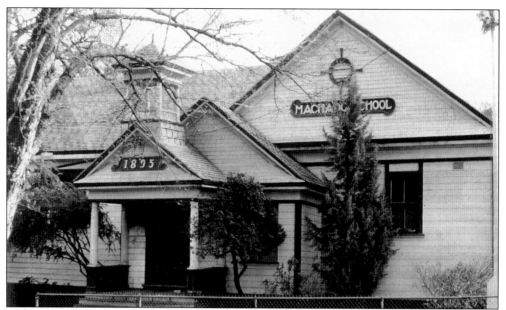

Machado School, located at 15130 Sycamore Avenue, is the oldest surviving school building in the district, founded in 1895. Bernard Machado was an early pioneer who married a Murphy. He donated land to build the school so that children wouldn't have to travel the distance to Morgan Hill Grammar School. Efforts are underway to preserve Machado.

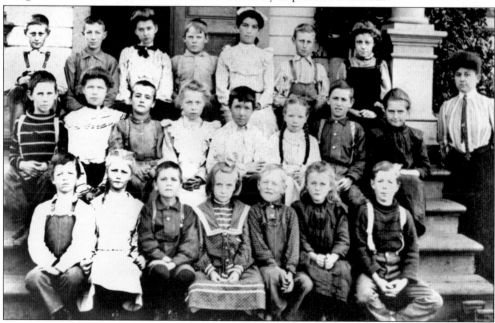

Machado students line up for posterity. Pictured, from left to right, are (front row) Harry Pavkoski, Maybelle Hislop, Clarence Gosvey, Margaret Rosmussen, Paul Ward, Alice Pierce, and Harold Ward; (middle row) George Thompson, Martha Pavkoski, Robert Rosmussen, Bernice Ward, Vivian Britton, Irene Britton, Chester Gosney, and Mabel Pierce; (back row) Peter Mosegard, Lynn Gaylord, Rose Gabordi, Bill Dembroski, unidentified, Walter Mosegard, and Winnifred Sutcliffe. The teacher was Lillian K. Biggs.

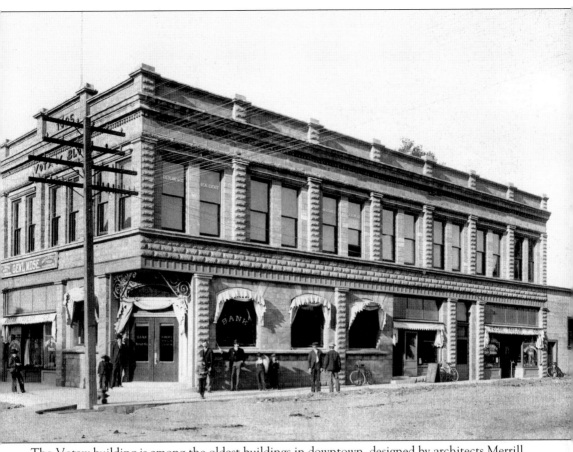

The Votaw building is among the oldest buildings in downtown, designed by architects Merrill and Bussing to house the first Bank of Morgan Hill. Messrs. E.J. and M.C. Votaw of Oklahoma built it in 1905, on faith that the city would soon be incorporated. Secure as a fort, the bank vault was literally built of railroad rails and concrete—some of which defied subsequent efforts at remodeling and remain fixed in the ground to this day. In 1909, the Votaws left Morgan Hill. The Bank of Morgan Hill continued until 1927, when it was purchased by the Bank of Italy, which became the Bank of America in 1930.

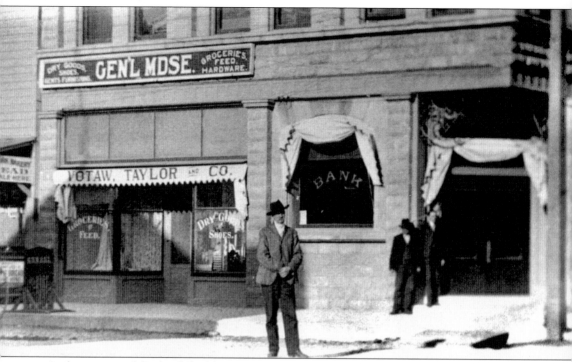

A closer view of the bank building reveals the general mercantile store, Votaw, Taylor, and Company. They sold groceries, cattle feed, dry goods, and shoes—the one-stop shopping formula that later led to supermarkets.

Three

THE FRUITFUL VALLEY

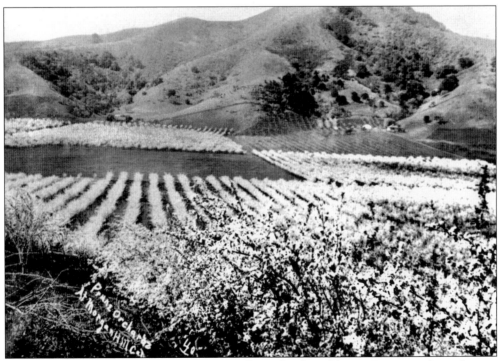

An early 1900s postcard displays Morgan Hill's orchards in bloom. During peak production years, the 1930s and 1940s, historians record that there were 100,000 acres of orchards in Santa Clara Valley. Louis Pellier of San Jose was partially responsible. In 1856, he returned to southern France to fetch his bride and also brought back prune roots of the *petit prune d'Agen*, a Turkish transplant that flourished in California.

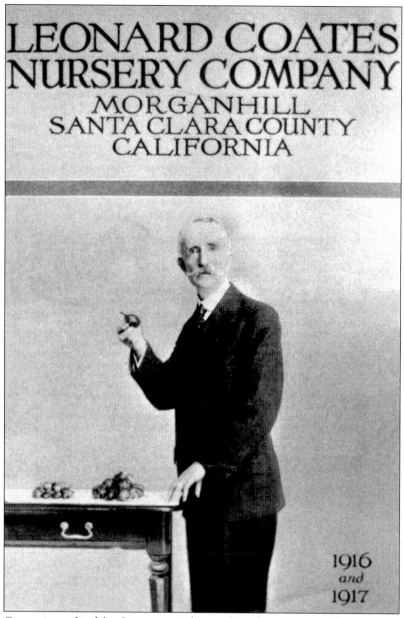

LEONARD COATES
NURSERY COMPANY
MORGANHILL
SANTA CLARA COUNTY
CALIFORNIA

1916
and
1917

Leonard Coates is credited by Sunsweet with significantly improving the cultivation of the prune, the basis for Santa Clara Valley's reputation as the "prune capital of the world." His first nurseries were in Napa and Fresno, but by 1908, he had moved to Morgan Hill, where he continued to test and refine grafting methods at his nursery on West Dunne until he retired. Peaches or almonds could be grafted with the prune for faster yields. Many Morgan Hill farmers purchased their prune trees directly from him. He was an authority on handling ripe fruit and drying it for the best taste, appearance, and economic yield. His instructions in the 1911 *Mercury Herald* newspaper read, "Be sure to allow the prunes to obtain all of the sugar they can from the trees by hanging until they drop of their own accord. Do not pick up until prunes are soft to the touch. These two rules are productive of nice, black prunes. They may not be black when gathered in the bins, but will color with age, without any foreign coloring matter."

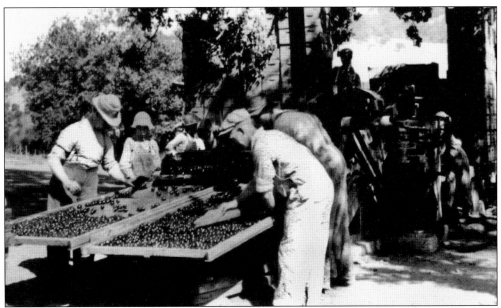

Coates was a gold mine of information. "Do not keep prunes in boxes overnight. They go through a sweat, and do not make a first quality of dried fruit, and take much longer to dry. It is better to let the prunes lie on the ground for several days than to let the picked prunes lie in the boxes over one night." Prunes were then dipped in lye, a step that was critical to the success of the harvest. The lye caused the prune to split. The trick was to split it just enough to aid drying. Coates advised, "The dipping fluid must be kept at the boiling point and no prunes put in unless it is boiling. It is not just a matter of how strong the lye is, but how hot is the water. Unless the dip is hot enough the prune will not immediately commence to dry, but will, in a few days become a chocolate color and refuse to dry."

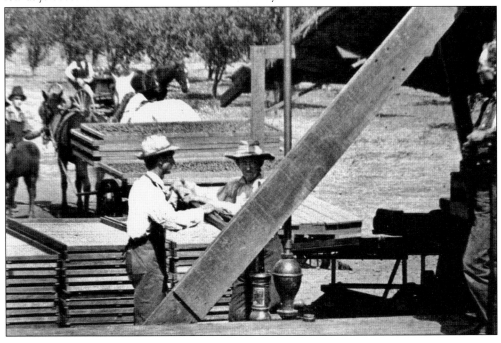

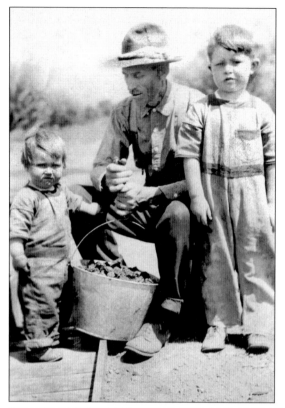

The process of harvesting prunes and drying them was arduous. Sometimes, machinery was used to shake the trees and the fallen fruit would be picked off the ground. If the fruit fell, you could assume it was ripe. In the 1920s image on the left, father Thomas Cheal and young Tommy and Helen hold a full bucket of fruit, reminding us that most farms were family owned and operated. The prunes were emptied out of the boiling tub of lye onto trays. At the Neilson Ranch on Watsonville Road in 1910, the prunes are being arranged on trays in preparation for laying them flat on the dry ground. There were no dehydrators and fruit was dried in the sun. Everyone watched the weather, day and night, while the fruit lay outside. Charles W. Stone was the manager. (Top photo courtesy Tom Cheal.)

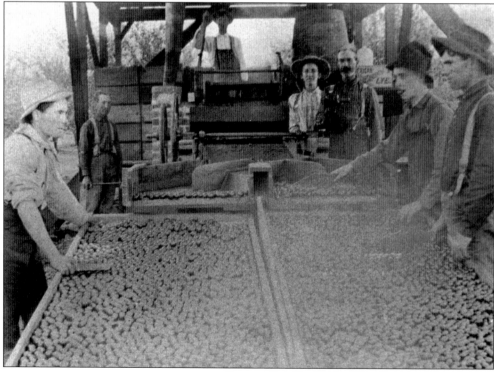

Prunes
1935.

	Lot 87		Lot 86	
8/6	13 Bxs		8/6 2 Bxs	
9	10½ "	23	9 1½ "	8
12	17 "	40	12 3½	7
16	43 "	83	16 6	13
19 }	102 "	185	21 } 107	120
20 }		235	23 }	
21	50 "			
24	44	279		
25	31	310		
26 }	54	364		
27 }	93	457		
28	59	516		
29		577		
30	61	591		
31	14			

25–26 Stacked Prunes at
¾ of rain 1–2 am

French

9/6 – 1 Bx
9/13 2 = 3

591	591
3	120
120	3
97	35
35	97
846	846

Paradise Hghts =
1418³

Sugars
8/9 – 1 Bx
23 – 10 – 11
31 – 7½ – 18
9/2 – 7½ – 26
3 – 9 = 35
#

– 2½ 13xs
– 8 = 10
– 12½ – 22
– 13 – 36
– 26 – 62
– 13 = 75
– 12½ 87
– 10 97½

On the night of August 25, 1935, there was a 15 percent chance of rain, according to Thomas Cheal's logbook. He was up at 2 a.m. stacking trays of prunes. And then it didn't rain after all. The crop was too important to risk any exposure to moisture during the drying period. Thomas Cheal was born in Chicago in 1868 and kept the books for the Southern Pacific Railroad in San Francisco before he came to Morgan Hill in 1906. Thanks to his meticulous records we have an insight into everyday farm life in the early 1900s. (Courtesy Tom Cheal.)

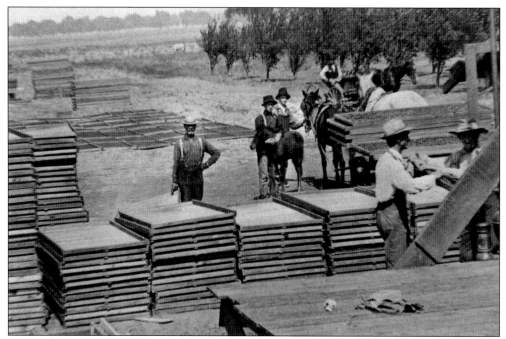

How long should the fruit remain out on trays? According to Leonard Coates, "Weather conditions govern the time prunes should remain on the tray. Grasp a handful of prunes and give them a gentle squeeze and open the hand quickly: if the prunes separate they are ready to stack the trays, and the fruit should be placed in the bin before it rattles on the trays."

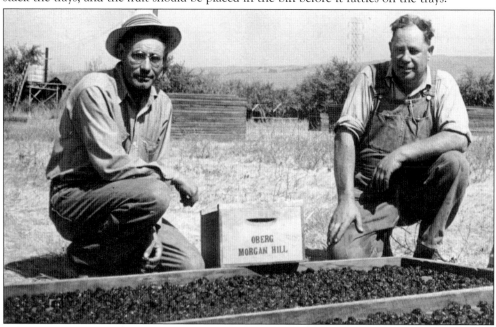

When the prunes were dry, they would be taken indoors, perhaps to a barn or shed, where it wouldn't rain on them. It was important to let the air circulate around them until they were packed. In this mid-1940s image, brothers Harold and Clarence Oberg are preparing to crate their sun-dried prunes at their farm on Miramonte Avenue.

Wood tracks were used for wheeling large wooden carts loaded with peaches to the sulfuring shed. Later, the fruit would be put into trays and sun-dried. Cheal's orchards were on San Pedro Avenue and Condit Road. (Courtesy Tom Cheal.)

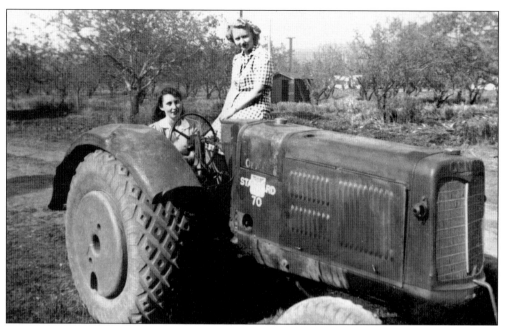

On a sunny, spring day in 1941, Marjory Lindsey visited her friend Helen Cheal on the Cheal farm. The two young women strike a pose on the Oliver tractor, which was new in 1936. Helen's older brother, Tom, remembers with sadness that she died in her twenties after drinking bad milk that hadn't been pasteurized. (Courtesy Tom Cheal.)

The Farmers' Union Store was located on Monterey Road in today's downtown district. Clyde Edes was manager of the hardware department, shown here with Jerry Butterfield, c. 1933. All sorts of farming supplies were sold here. The store also supported farmers by arranging credit, with the following season's crop as collateral.

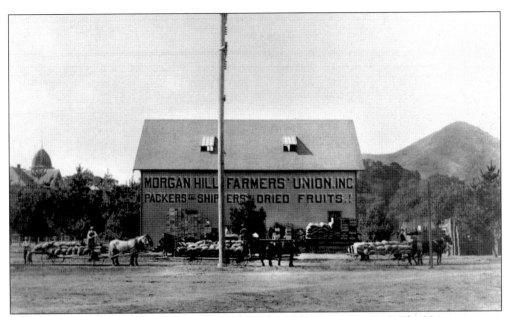

Farmers unloaded dried fruit at the Morgan Hill Farmers' Union, *c.* 1915. The Union was one of 10 local branches in Santa Clara County that sold its produce to the California Farmers' Union of San Francisco, which was part of the National Farmers' Union. The Union set higher prices for buyers and negotiated cheaper shipping rates with the railroad to help farmers increase their profit margins.

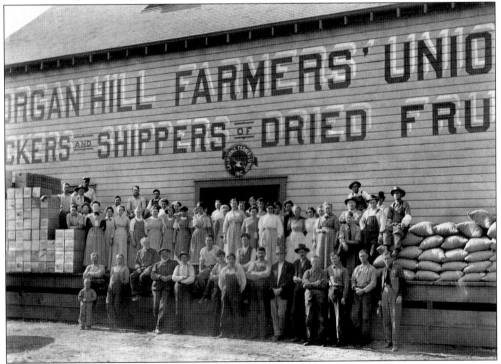

This is a closer view of the Farmers' Union Packinghouse with the workers lined up outside. Unfortunately, we do not yet have a record of their names.

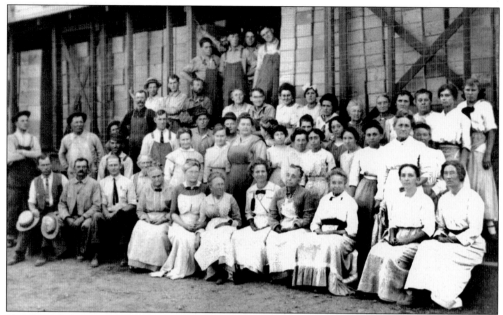

On the other side of the Farmers' Union building, everyone takes a break. Note the wooden crates of sun-dried fruit stacked in the background and ready for shipping.

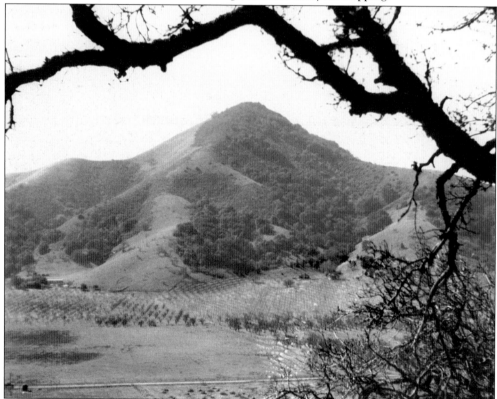

Here is a uniquely symmetrical 1920s view of El Toro Mountain as seen through the branches of an old prune tree whose shape naturally frames and repeats the shape of the mountain.

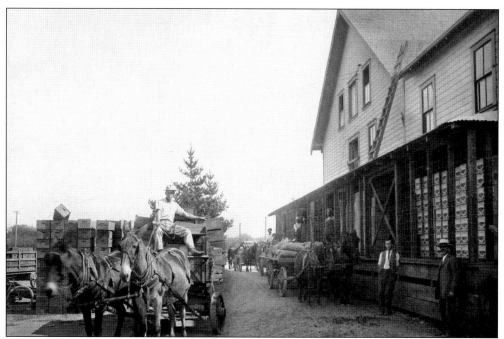

The Farmers' Union building, shown here, was a hub of activity. It was conveniently located near the Sunsweet building on East Third Street. The California Prune and Apricot Growers Association was a cooperative formed in 1917. They packed dried fruit under the brand name Sunsweet, with their headquarters in San Jose. At one time Sunsweet processed 75 percent of the state's agricultural crops, including peaches and prunes.

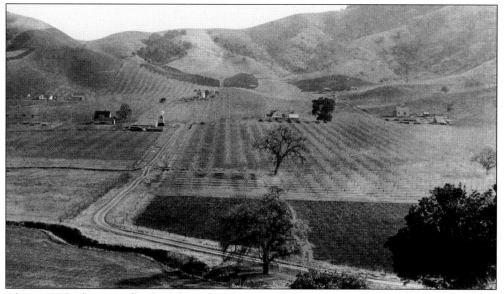

About 1905, this stretch of road in the Llagas Valley was known as Walker's Grade, after George Walker and his family, settlers from Massachusetts. They built two houses on the property. Today, the road is known as Llagas Road and Little Llagas Creek is the narrow ribbon weaving through the foreground. The northern face of El Toro Mountain rises up in the background.

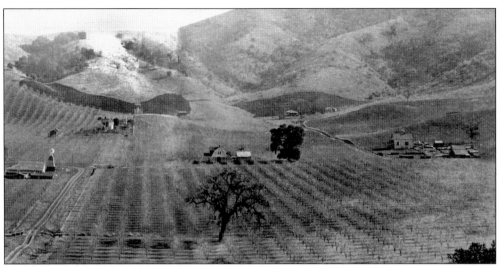

A closer view of Walker's Grade reveals the small windmill beside the house. Before there were deep well pumps with electric motors, farmers experimented with harnessing the powers of wind to irrigate the land and provide water for homes. Windmills pumped water into troughs for cattle, into a tank for household use, or to a large elevated tank for community use.

By 1896, Morgan Hill houses closer to downtown received water through a system of pipes owned by L.M. Hale. The pipes drew on water from mountain springs several miles to the northeast. Some families kept their windmills, just in case. This picture from 1916 shows a timeless combination—a baby, a water hose, lots of sun, and a puppy. (Courtesy Tom Cheal.)

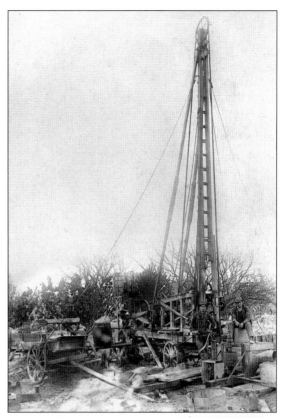

This undated image, probably from the late 1800s, shows the construction of a well with a windmill. Valley farmers began experimenting with windmills in the mid-1800s. Prior to that, most wells were artesian—underground water pressure was sufficient to force it to the surface. The *San Jose Mercury News* records "gushers" coming up in the middle of San Jose. In 1896, a farm near Gilroy belonging to Samuel Rea reportedly had four artesian wells, starting from a depth of 150 feet. In 1952, Anderson Dam (below) was built across the waters of Coyote Creek to conserve water, an effort to recharge aquifers beneath the Santa Clara Valley.

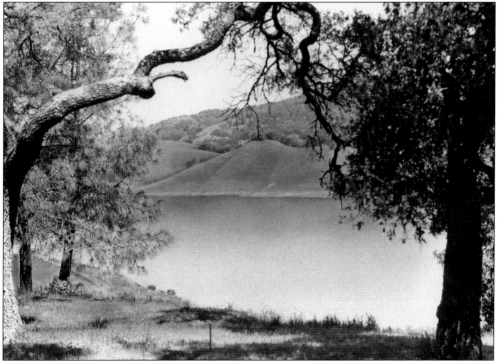

The Cochrane-Jackson Ranch was built in 1904 by Aphelia Cochrane. Aphelia was the family matriarch, who started with 1200 acres and built up the ranch to 5500 acres. Holiday Estates and Jackson Oaks have sprung up where the ranch once was. Aphelia also wrote news articles and a book about her childhood growing up in Maine and her trip to California. She lived to be 104. One of her daughters married into the Jackson family and lived in this house beside Coyote Creek. In 1952, at the time of the construction of the Anderson Dam, the house was moved to its present site, shown here.

Four
ISOLA AND THE LION

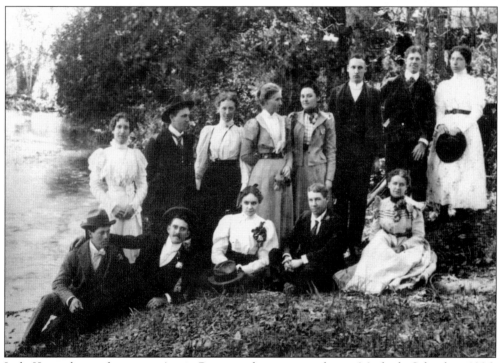

Isola Kennedy stands next to Annie Britton, who was a teacher at Machado School, *c.* 1906. Friends gathered beside Llagas Creek in Paradise Valley to record a happy day. From left to right are (front row) Fred Deane, Will Kelley, Edith Sweetland, (?) Hares, and Rose Gorham; (back row) Sophy Deane, Bert Purcell, Annie Britton, Isola Kennedy, Clara Kelley, Ralph Sweetland, Reg (?) Hares, and Grace Deane.

Isola Kennedy was engaged to Dr. Otto Puck. The couple attended an Epworth League Party at the home of Mr. and Mrs. Will Bone. The theme of the party was "Around the World." Everyone came in costume. Dr. Puck and Isola wore coordinated outfits.

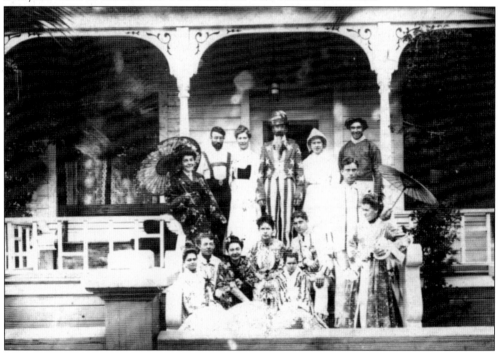

Isola Kennedy stands to the left of Uncle Sam in another party scene. Isola was a well-known temperance worker throughout Santa Clara and San Mateo counties. One hot Monday afternoon, on July 6, 1909, she took five young boys from her Sunday school class for a cool swim at the beach at Coyote Creek. While several of the boys were splashing about, a lion appeared.

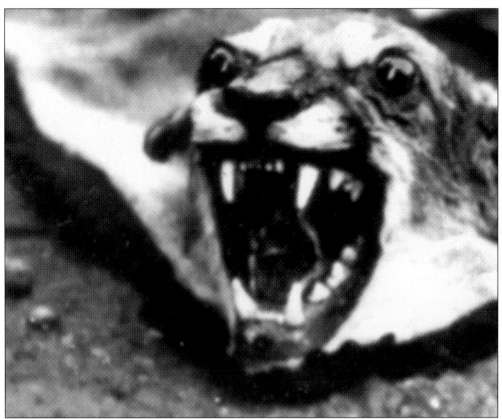

The lion clawed one of the boys, leaving a long gash on his head. Isola stood up, but the lion swung a forepaw and struck her back to the ground, sinking his teeth into her arm. She jabbed at him with an eight-inch hatpin. Fighting, Isola screamed to the boys to run. The frightened boys got help from Jack Conlan, at a camp nearby, telling him that a big cat had attacked them. Conlan ran to the scene with his shotgun and saw Isola lying on the beach with the lion on top of her clawing and chewing her shoulder. He fired a charge of birdshot into the lion's flank. The lion did not pause. In an agonized voice, Isola said, "Don't shoot me." In desperation, Conlan slammed the lion with the gun butt. His blows had no effect. Conlan ran back to the camp for a rifle. Finally, he fired into the lion's shoulder. The brutal head raised at the attack. Conlan fired into the lion's brain. The episode lasted fifteen minutes. Isola was still conscious. This is a photograph of the actual lion. (Photo courtesy Joyce Hunter; story courtesy Joyce Hunter, *Morgan Hill Times*.)

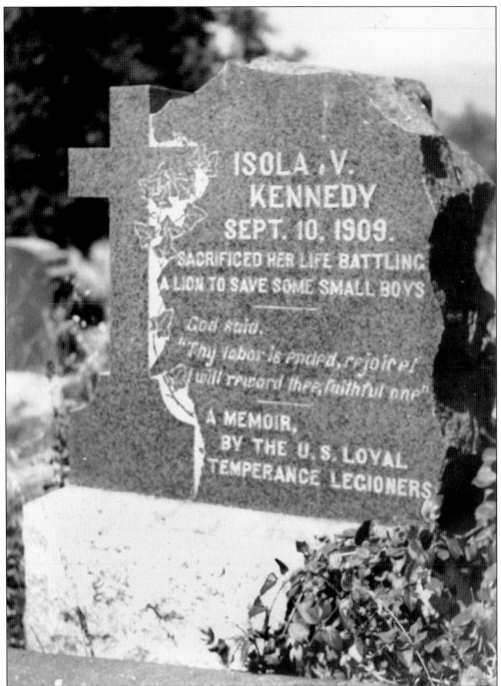

ISOLA.V.
KENNEDY
SEPT. 10. 1909.
SACRIFICED HER LIFE BATTLING
A LION TO SAVE SOME SMALL BOYS

God said.
"Thy labor is ended, rejoice!
I will reward thee, faithful one"

A MEMOIR,
BY THE U.S. LOYAL
TEMPERANCE LEGIONERS

Isola's injuries were not at first thought to be fatal. What finally caused her death, and that of the Wilson boy, were deadly rabies germs in the mouth and claws of the lion. On September 10, 1909, she died, two weeks after Wilson died of lockjaw. Her tombstone inscription was placed by the U.S. Loyal Temperance Legioners: "Sacrificed her life battling a lion to save some small boys." Her fiancé, Dr. Puck, pictured on page 62, left for Texas at the time of the attack and never returned.

Five
CITY AND COMMUNITY

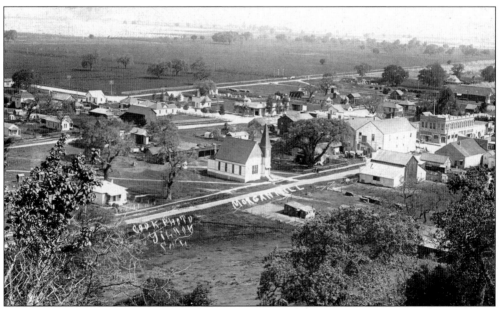

In November 1906, the people of Morgan Hill cemented their future as a community by voting to incorporate. With more than 500 inhabitants, they fulfilled the population requirements for a city. When it was time to vote, dissenters objected that taxpayers would have to fund extravagant water systems and unnecessary sidewalks. Nevertheless, the majority voted in favor of the proposition. The settlement formally declared itself the City of Morgan Hill.

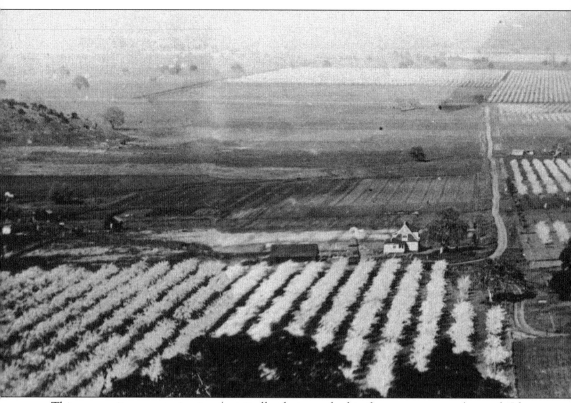

This composite panoramic view (originally photographed in four separate parts) reveals Llagas Valley as it was *c.* 1907, in the area that is now northwest Morgan Hill. Llagas Creek was named during the Spanish period, in the 1700s, by Franciscan friars who established missions throughout the state, all connected by one long dusty road, the El Camino Real, or the King's

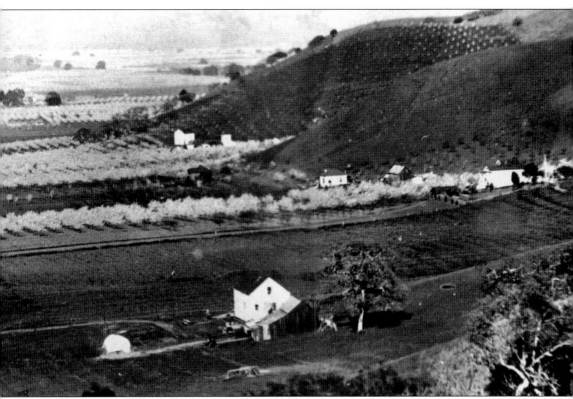

Road. In Morgan Hill, the El Camino Real is called Monterey Road. The missionary fathers named the area Las Llagas de Nuestro Padre de San Francisco, which translates as the stigmata of our patron Saint Francis.

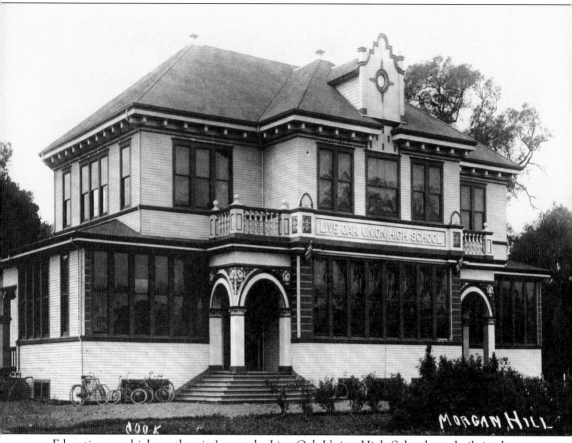

Education was high on the city's agenda. Live Oak Union High School was built in the same year that the city incorporated, 1906. The school served a union of five school districts needing education for older children, a sign of a growing community. Children were drawn from Machado, Llagas, Burnett, Encial, and Morgan Hill Elementary Schools.

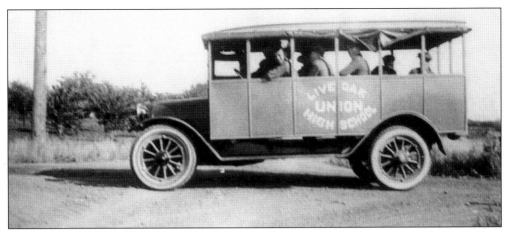

The Live Oak Union High School bus followed a bumpy, circuitous route around the ranches. Most children worked on the family ranch before and after school. Seasonal chores included picking prunes and cutting apricots (or "cutting 'cots," as it was called) to earn money. One of the town's founders recalls earning enough to buy a bicycle, freeing him to help his widowed mother with farm chores. He attended school when and if his "real home work" was done.

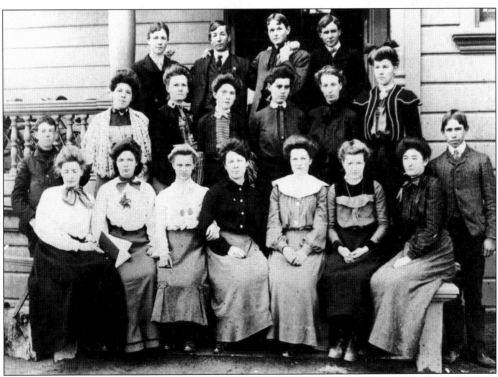

Miss J. Merritt was a teacher at Live Oak Union High School in the early 1900s. Pictured, from left to right, are (front row) Irma Pettit, Olive Norton, Florence Weichert, Nellie Stone, Jane Walker, Gertrude Dunipace, Jennie Castillon; (middle row) Jack, Lois Kinhead, Miss Merritt (teacher), Maedell Breton, Ruth Ward, Ethel Weichert, Jennie Munson, Alfred Dean; (back row) Irwin Payne, Ralph Weichert, Raymond Garrett, and Floyd Stone.

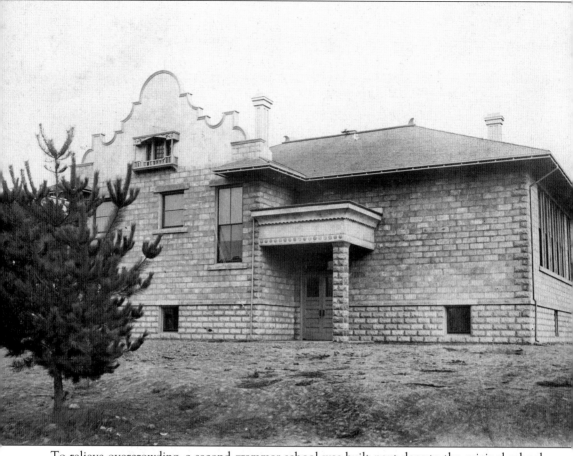

To relieve overcrowding, a second grammar school was built next door to the original school in 1904. Constructed with sandstone blocks, it cost $8,000. In 1926, the Morgan Hill Grange bought the building. It suffered damage in the April 1984 earthquake and with the assistance of the City of Morgan Hill, the Grange completed repairs in 1986. The building has since been extensively remodeled. This image is from the early 1900s.

This view shows Morgan Hill Grammar School's kindergarten class of 1923. Norma Edes (back row, second from right) was happy at school and couldn't wait to learn to read. Her grandfather was George Edes, publisher of the newspaper that later became the *Morgan Hill Times*. (Courtesy Norma Edes Link.)

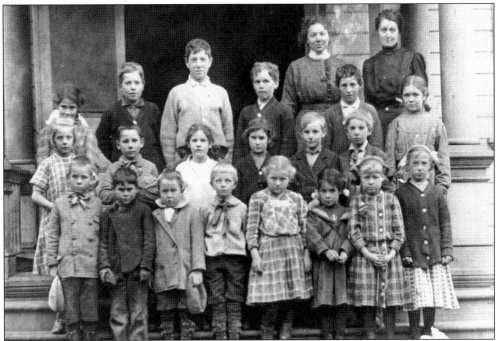

This view shows Morgan Hill Grammar School in 1910–1911. Every girl wore a ribbon in her hair that day and every jacket was buttoned up just right. The two gentle-faced teachers taught a class of 20 children of mixed ages.

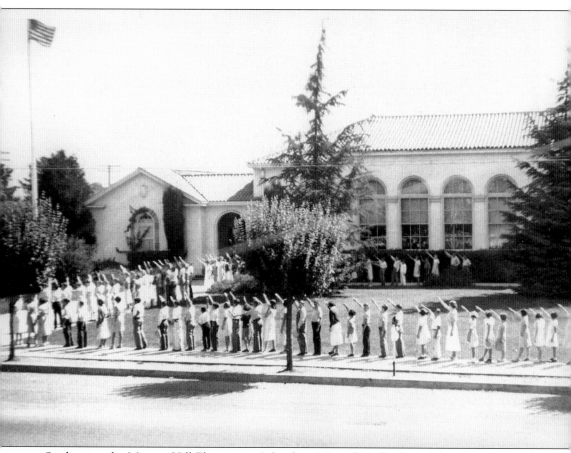

Students at the Morgan Hill Elementary School in 1931 salute the flag, with right arm raised, centurion style. After World War II, the school salute was thought to be too similar to Hitler's, so it was altered to the hand-on-heart pledge. The building has been preserved and moved from its original location on Monterey Road to Llagas Road. (Courtesy of Muriel Allen, teacher and mother of Jean Allen Rice.)

Lloyd Skeels served as the constable of Morgan Hill and Burnett Township (later annexed by Morgan Hill) in the 1920s and 1930s. One of his jobs was to halt all traffic, wagons, and automobiles while Henry Coe's cattle thundered down from the hills and across the road to Madrone Station.

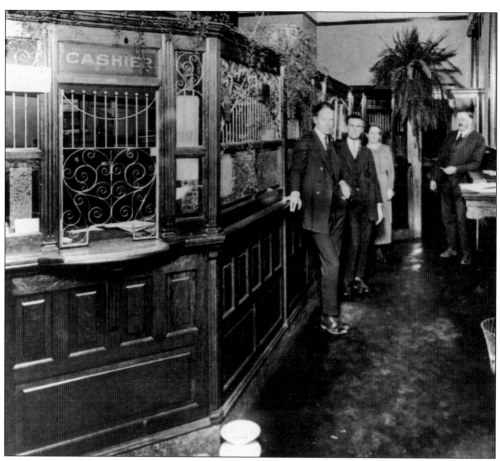

As the community grew, downtown businesses also thrived. The polished interior of the Bank of Morgan Hill in 1922 has an air of prosperity. Bank employees, from left to right, are Carl Nelson, Chester Carmean, Edith Reid, and the manager, Mr. Drury. Bank checks were typically accepted by most people in town, since they usually knew one another. There were no encoded account numbers on the checks as we can see from the one below, written in 1914 to pay for cutting one cord of wood. (Courtesy Tom Cheal's Collection.)

Morgan Hill, Cal., _Feb 28th_ 1914 No. 16

BANK OF MORGAN HILL 90-637
COMMERCIAL AND SAVINGS

Pay to _J. Peno_ _____ or Order, $7.50

Seven 50/100 _____ Dollars

H. A. Weller

BURKE PTG. CO., FREDONIA, KS.

For 1 Cord Wood

74

In 1915, Dr. W.D. Miner built his home just north of the United Methodist Church and the house is still there. He practiced in Morgan Hill for 20 years, serving the town and rural community for miles around. The advent of automobiles made house calls somewhat easier by this time—at least where there were drivable roads.

A young woman steps daintily from a car on Monterey Road, between the Methodist church and Dr. Miner's house on June 19, 1927. The road was a narrow trail at this time. Later, as the popularity of cars increased, the city widened the road by using horses and ropes to drag most of the buildings on this side, including Dr. Miner's house and the church, back 17 feet.

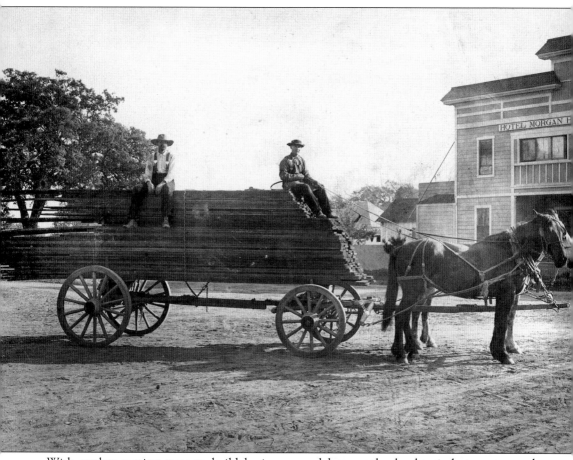

With settlers cutting trees to build businesses and homes, the lumber industry prospered. Lumberyards opened to plane and size wood. Emil Johnson is driving the wagon shown here and moving lumber to Bill Bone's lumberyard in front of Morgan Hill Hotel on Second Street. Lumber was a heavy load to haul. Often, 10 to 12 horses were needed to move a heavy wagonload. The horses wore bells on their harnesses to alert others using the road.

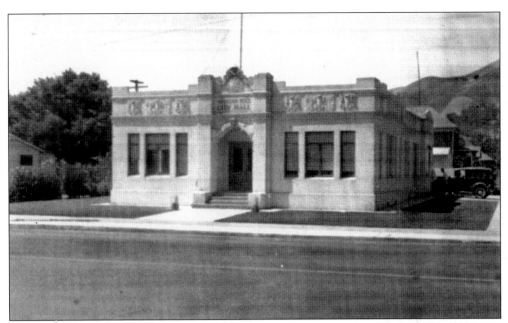

During the Great Depression of the 1930s, Morgan Hill went ahead with its plans for a new city hall. It was built on the corner of Main Street and Monterey Road. The police department was in the rear.

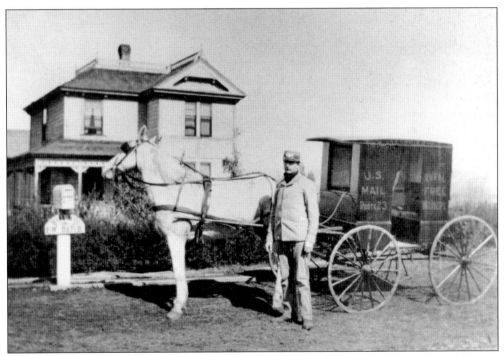

Vertie Edes, the first rural mailman, is delivering letters to the Hatch's house on Dunne Avenue in this c. 1910 photo. Vertie was quite active in the community. He was one of the sponsors of the Morgan Hill Rodeo, an event that drew professional cowboys from around the nation. Another photo of Edes (performing in community theater) is on page 43.

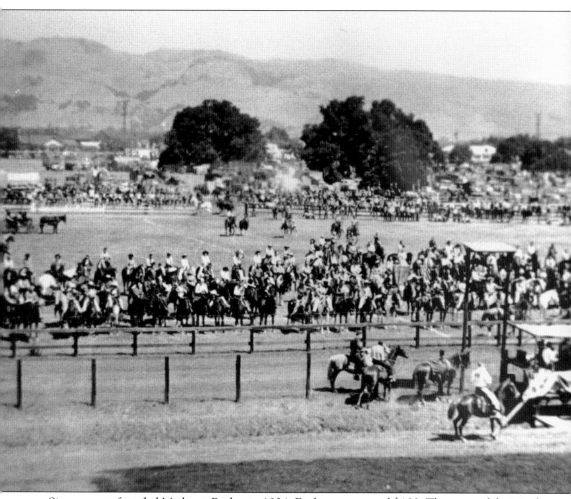

Sixteen men founded Madrone Rodeo in 1934. Each one invested $100. The original financial backers were J.W. Sheldon, Ernest Magincaldo, T.J. Kirby, Lloyd Skeels, P.R. Thomas, Alfred Jackson, John Sebben, Harry Skeels, V.M. Edes, Pat Kirby, Hartley Weichert, John Selmas, Ralph Slaughter, Henry Wendt, Victor Raggio, and John Saliemento. The rodeo was held on Hale Avenue. (Courtesy Leon Thomas.)

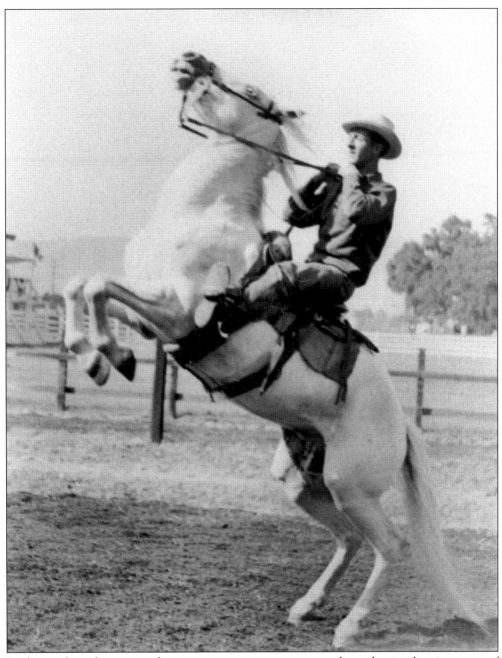

Professional cowboys came from many states to compete at the rodeo in the tiny town of Madrone, north of Morgan Hill. Madrone was annexed to Morgan Hill in the 1950s. These images, taken between 1934 and 1942, pay homage to the cowboys' skill, daring, and pure showmanship. (Courtesy Leon Thomas.)

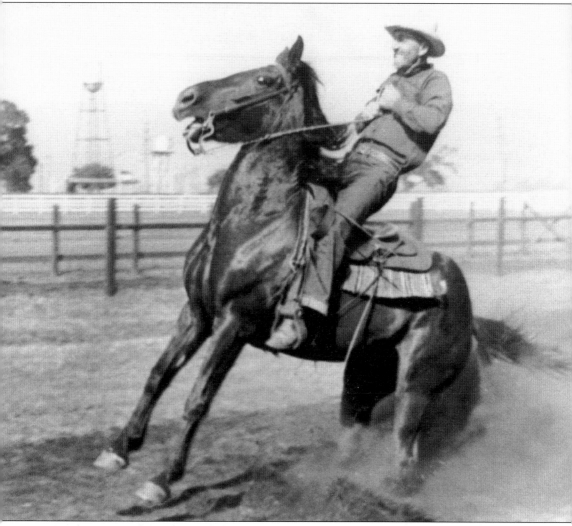

"It takes time and patience and close observation of the good points of a horse to train him to a high degree of efficiency. [The horse] has to be swift of foot, obedient to the least touch of the reins, the pressure of the knees and the sway of the rider." This is a quote from Martin Murphy Sr. on the skills of horse and horsemen in herding cattle, provided by Marjorie Pierce. (Courtesy Leon Thomas.)

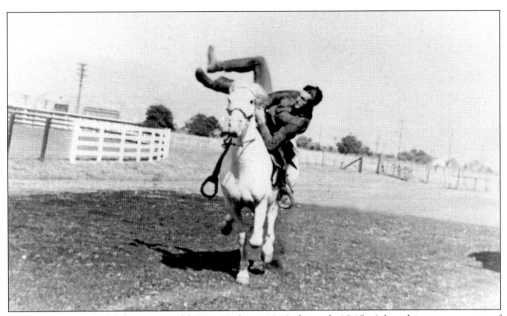

No rodeos were held during World War II, from 1942 through 1945. After the war, a group of sponsors held two unsuccessful rodeos that ended the annual tradition in Madrone. In its heyday, the rodeo showcased the complex communication possible between a horse and rider, skills that tipped the balance between life and death on a cattle drive. The festive atmosphere, parade, dances, and barbeques brought crowds of people to town. (Courtesy Leon Thomas.)

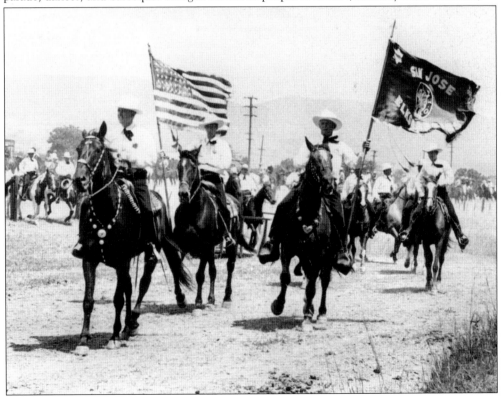

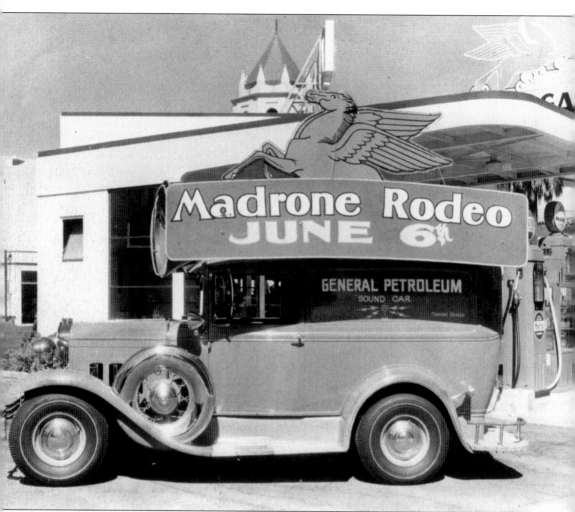

A sound car flaunts a flying horse and promotes the rodeo, which was held on the J.W. Sheldon Ranch on Hale Avenue and included wild steer racing, bull riding, roping, and horse racing. Professional rodeos were held each year in May from 1934 until 1941. (Courtesy Leon Thomas.)

The Ward family's first automobile was a 1910 Model-T Ford. Harold Ward, on the right, is nattily dressed in appropriate motoring attire, having just driven the dirt roads winding through the fruit trees to visit his friend Ray Kelley. The Model T was known colloquially as "Tin Lizzie" for its tough body made from a lightweight steel alloy. The car might break down, but it would not break apart. The four-cylinder motor produced 20 horsepower for a top speed of 45 m.p.h.—an unforgettable experience on curving, bumpy, mountain roads. A typical speed was closer to 30 m.p.h. In 1909, Henry Ford said, "I'm going to democratize the automobile." By 1912, a Model-T Ford could be purchased for $575, less than the average annual salary. By 1914, the assembly process was streamlined even further and it took only 93 minutes for the factory to assemble a car. This also served to push down the cost and increase the popularity of the automobile.

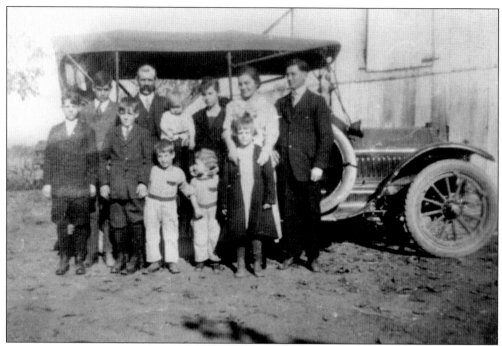

The Tallmon family's first car was a 1914 Studebaker that carried seven passengers. It was purchased from Bernie Amburn who had used it as a stage in a run from Morgan Hill to San Jose. Pictured here, from left to right, are (front row) John, Willard, Donald, Alice, and Susan Tallmon; (back row) Raymond Tallmon, George A. Tallmon (with Dorothy T. in his arms), Bessie and Edith Tallmon, and Arthur Jones. The image below spans one generation of the Tallmon family.

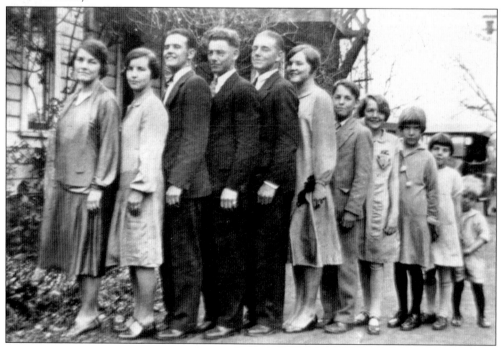

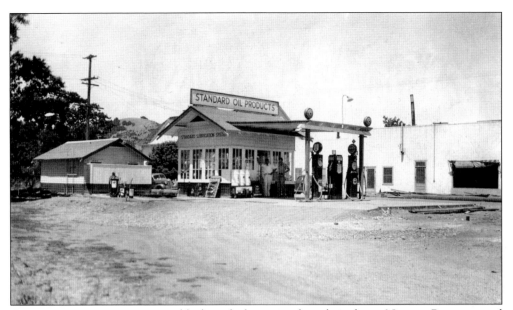

Gas stations came into vogue as blacksmiths began to close their shops. Newton Bryan opened for business in the late 1920s. He owned and operated Standard Oil Products, shown here on July 4, 1938. One year in the mid-1950s, there was a gas war in town. To shut down the competition, Standard Oil lowered their gas price to 13¢ a gallon.

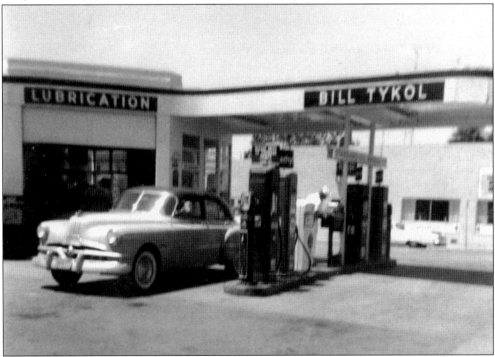

Concern for the happiness of his family kept Bill Tykol, Mr. Bryan's son-in-law, in Morgan Hill when he returned after World War II, even though there were more jobs in San Jose. He began working at Standard Oil and eventually purchased the gas station from Bryan, refitting it for modern service. The station was on the corner of Monterey Road and Encino, now First Street.

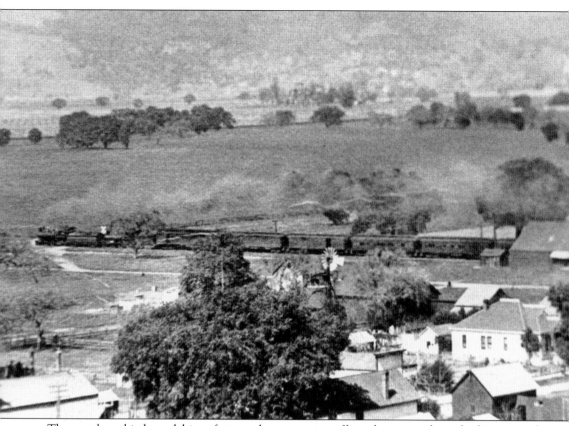

The regular whistle and hiss of steam locomotives puffing their way through this pastoral community could be heard from the mid-1800s to the mid-1900s. In the 1800s, California's economy relied heavily on mule teams, stage coaches, and steamboats until the railroads were built. The first transcontinental railroad was built by the Central Pacific Railroad after much surveying and federal lobbying. It was built through the same mountain pass in the Sierras through which Martin Murphy Sr. had traveled with his family in 1844. The groundbreaking for the transcontinental railroad was in Sacramento in 1863. The Southern Pacific Railroad began a separate company, founded in 1865 by businessmen in San Francisco, to connect their city with settlements to the south as far as San Diego. One of those settlements became the city of Morgan Hill, shown above in the 1920s. The Southern Pacific Railroad's first diesels came into mainline service in 1947, and the last steam locomotive was retired in 1957.

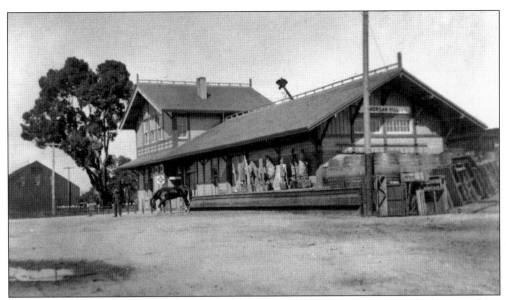

A horse and rider are waiting for a train at the Morgan Hill Depot in this undated image from the turn of the century.

The bells along Monterey Road remind us that it is a portion of the original El Camino Real, the 700 mile-long, dusty highway that linked the California missions. The bells were first installed in 1906 as a historic guide to mark the trail so that it wouldn't be lost among new urban streets. This old bell is outside Morgan Hill House at 17860 Monterey Road.

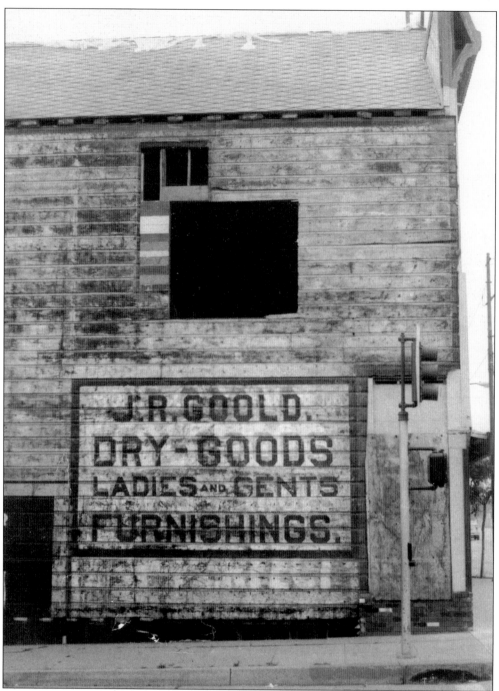

In 1983, old advertising signs were revealed during a renovation of the Millhouse Mall, then owned by Ralph Lopez. The building is one of the oldest downtown and has been on the corner since 1902, when it was first owned by Charles Mason (see page 41). We can date the Goold advertising signs to the period between 1920 and 1944, when John Goold owned and operated a department store on the corner. This sign and the one recovered for Levi jeans (page 89) are now displayed at the back stairs entrance on Second Street.

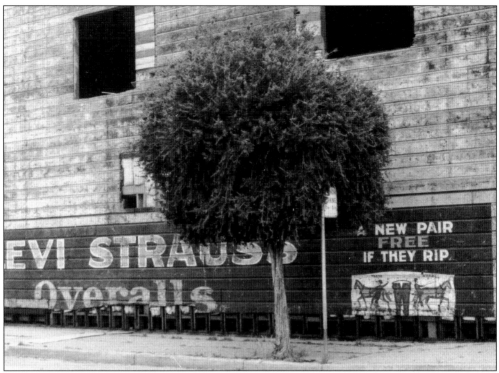

The same renovation uncovered an old colorful logo for Levi Strauss overalls, along the same wall on Second Street, reminding us that denim pants were first made for ruggedness rather than fashion. Levis were the first patented workpants reinforced with metal rivets to keep them from ripping—suitable for panning gold on your knees all day, for breaking in wild horses, and picking prunes off the ground. The Millhouse Mall was also called Mason & Triggs (pictured below and on page 41) in 1905.

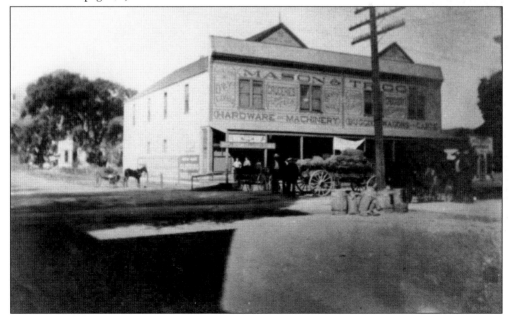

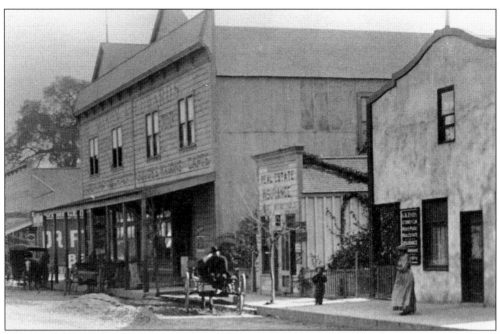

By 1907, the corner on Monterey Road and Second Street was anchored by Mason and Edwards, purveyors of buggies, wagons, and carts. F.V. Edwards bought out Triggs in 1907. Edwards and his sons and son-in-law ran the store until 1912. Ray Lopez restored the building extensively in the 1970s, uncovering the original windows and resurrecting the charm of the long, portico over the sidewalk. To the right of Mason and Edwards was A.C. Sterrett's real estate, loans, insurance, and notary public business, also shown below.

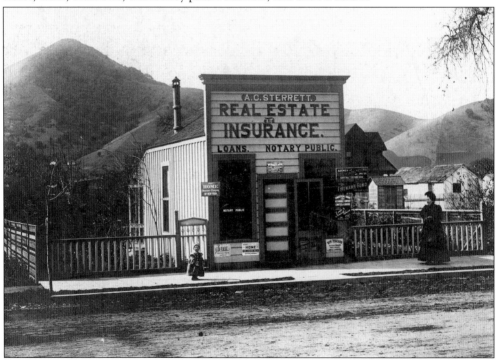

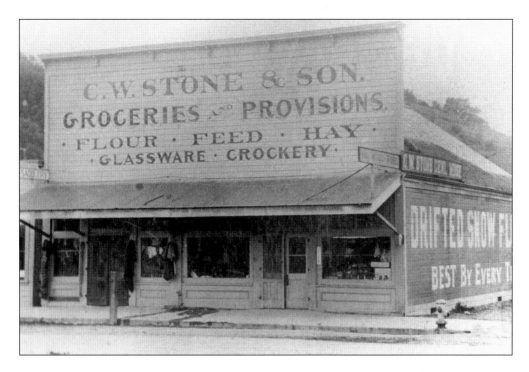

The southwest corner of Monterey Road and Second Street has also had many manifestations. In about 1907, it was Stone's. It has also been Edes's and Telfer's grocery store. The building was moved from another location to this corner and has been remodeled many times. The sign on the right side reads "Drifted Snow Flour." The Mason & Triggs store across the road on the northwest corner, below, is advertising the specials of the day—millinery and dry goods.

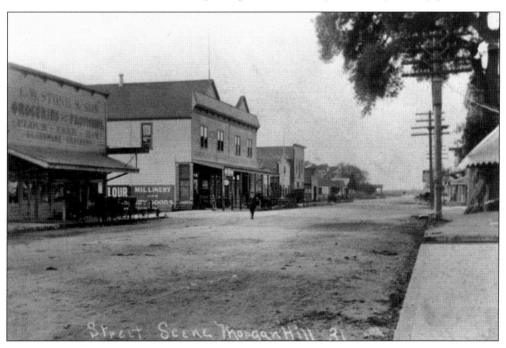

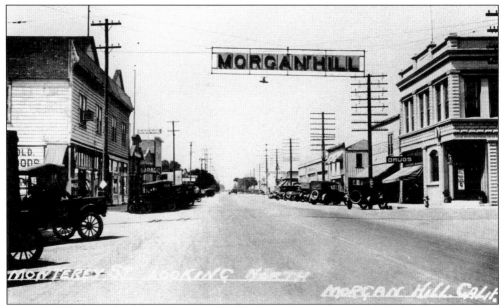

To welcome incoming traffic, the entrance to the city was marked by an overhead sign near the corner of Monterey Road and Second Street. John Goold bought the Mason and Edwards buggy and wagon store in 1920 and replaced it with a department store, barber shop, county library branch, and jewelry and watch repair business. Goold was a city councilman and organist for the Methodist church. He sold the department store in 1944 and the watch repair business in 1947. Note the abundance of automobiles by the 1920s. Mass production and assembly lines had made cars more affordable. In the 1920 image below, Jennie Castillon and Effie Bordevoue are ready to roll.

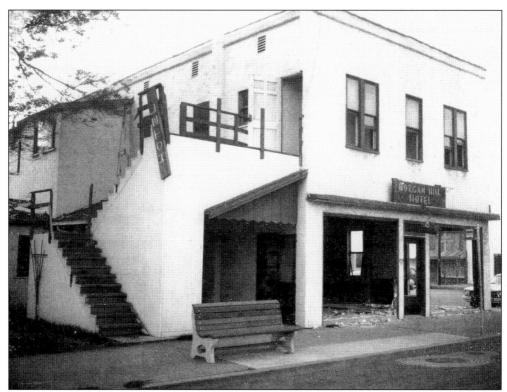

The most devastating earthquake in Morgan Hill was in 1984 when a temblor of 6.2 on the Richter scale started from an epicenter eight miles northeast of Morgan Hill. Several buildings in the oldest part of downtown were damaged. Morgan Hill's most famous quote about earthquakes is that of young resident Mary Gordon, who was awakened by a jolt from the San Francisco earthquake of April 18, 1906. She said to her mother, "I have no use for earthquakes."

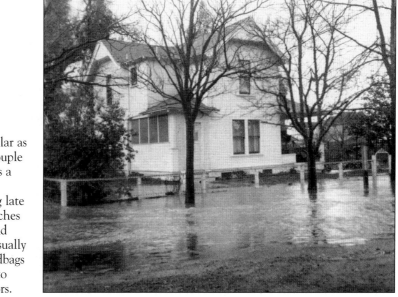

Flooding is as regular as heavy rain on a couple of low-lying streets a few blocks from downtown. During late fall and winter, inches of water puddle and pool. People are usually prepared with sandbags and a willingness to help their neighbors.

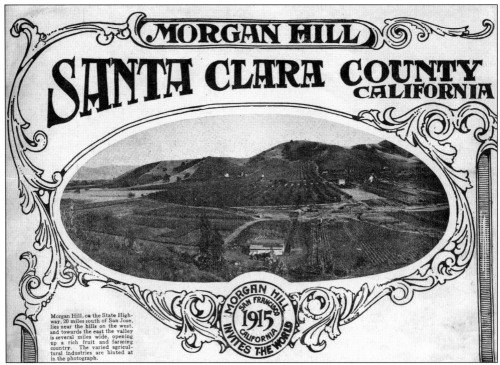

Morgan Hill, on the State Highway, 20 miles south of San Jose, lies near the hills on the west, and towards the east the valley is several miles wide, opening up a rich fruit and farming country. The varied agricultural industries are hinted at in the photograph.

"Morgan Hill Invites the World," reads the slogan on a brochure published by the Morgan Hill Board of Trade in 1915. The sponsoring merchants included Leonard Coates Nursery, A.B. Imus Hardware (which also sold windmills), Edes Brothers Family Grocers, John Telfer General Blacksmithing and Horseshoeing, and D.D. Powell, pigeon farmer.

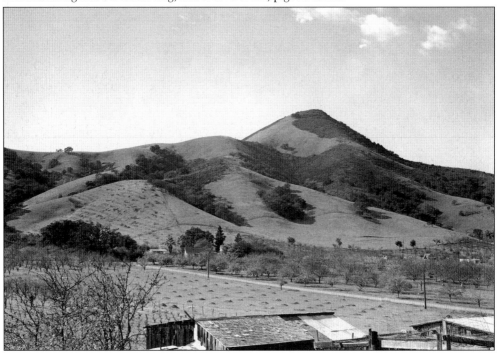

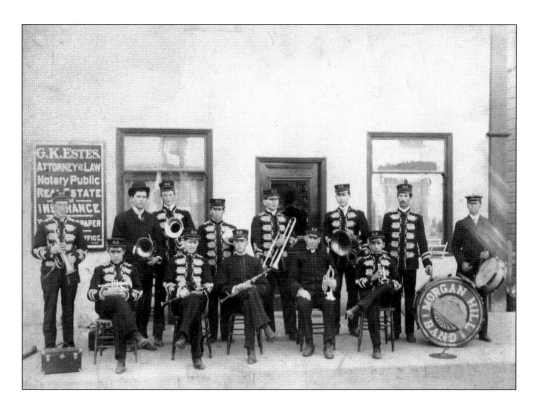

The men of the Morgan Hill Band played regularly downtown and could be heard practicing with gusto behind the Farmers' Union Building. Will Hatch, Charlie Hatch, and Uncle Hatch were members when this photo was taken on Monterey Road in the early 1900s. The 1912 view of downtown and easter valley was taken from Nob Hill.

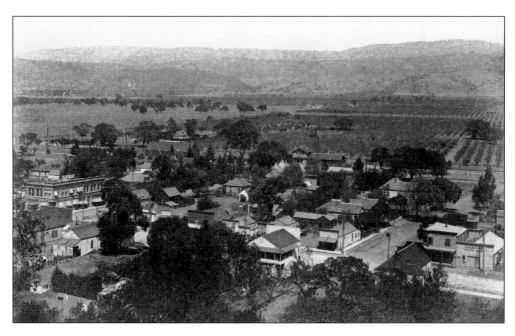

April 1923 saw the construction and opening of the city's palace of dreams, the Granada Theatre on Monterey Road, downtown. The architect was Chester H. Miller. To the right is P.O. Muehmel's Paint Shop. That year the latest and greatest box-office hits were *Robin Hood*, starring Douglas Fairbanks, *Why Worry*, with Harry Lloyd, and *The Pilgrim*, with Charlie Chaplin. The image below is from 1926.

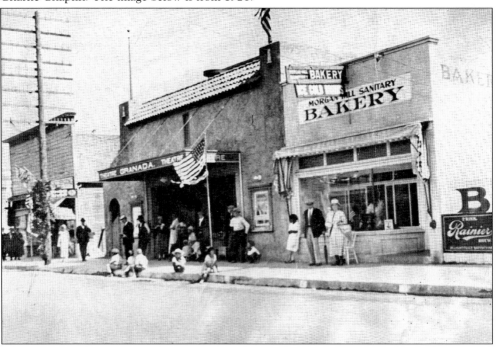

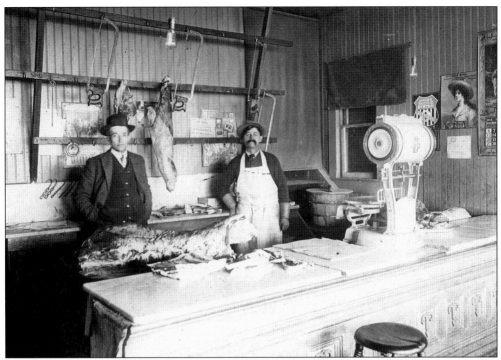

Around 1914, Francois Marie Tremoureux (at right) and Thomas Bennet operated a meat market on Monterey Road. We are fortunate to have an image of the exterior of the market as well, shown below.

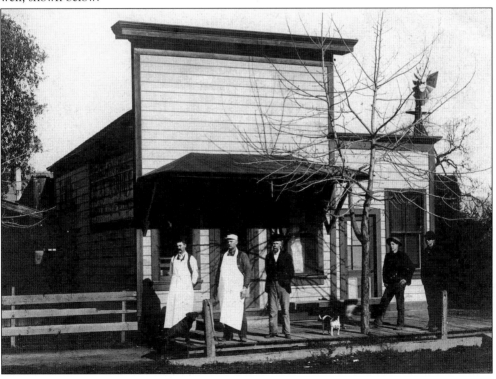

More recent occupants of the Votaw Building have included the Morgan Hill Unified School District, South County Realty, and Merle Norman Cosmetics. Since the building was restored in 1985, it has housed The Coffee Roasting Club, Dottie's Sportswear, H&R Block, Bearly Worn, Bebes and Miniatures, Escobar Signs, and Weston-Miles Design.

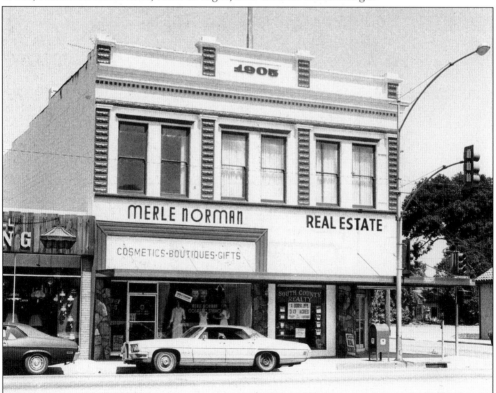

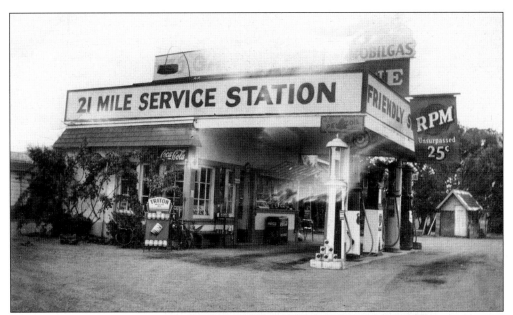

The southwest corner of Tennant Avenue and Monterey Road used to be the location of 21 Mile House, a stagecoach stop, hotel, and barroom named for its distance from the San Jose terminus. It was owned and operated by John Tennant, a former piano tuner from County Wexford, Ireland, and a friend of the Murphy family. After the inn was torn down, this gas station kept the old name alive. The picture above is from October 22, 1936. Today, the gas station is gone as well. The site is now marked by a memorial plaque and two spreading oaks. The notorious outlaw Tiburcio Vasquez is said to have frequented the barroom, emptying the tills and terrorizing people until he was arrested for murder in 1874 and hanged.

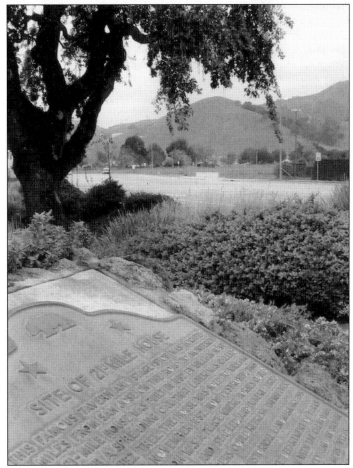

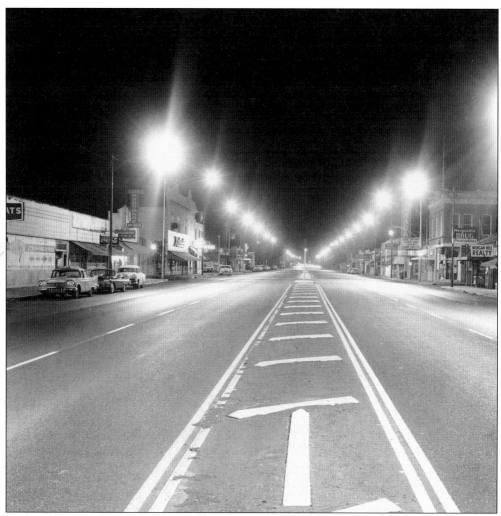

Looking north from Third Street and seeing clear black asphalt without a car in sight was a moment worth recording in 1958. Monterey Road through downtown was widened in the mid-1930s to alleviate traffic congestion and accommodate traffic to and from the burgeoning Bay Area. Old timers recall that 30,000 to 40,000 cars a day passed through downtown. The city's first traffic fatality in 14 years happened soon after the road was widened. The *Morgan Hill Times* records that 86-year-old George Burnett was killed when he was struck by a vehicle at Monterey Road and Encino, now First Street. A month later, Amanda Petrocchi, 55, was killed when she attempted to cross through the streaming traffic. Mayor John Telfer was hit by a car in 1942 at Monterey Road and Second Street. The state finally installed the first traffic light in the city at that corner to slow drivers. By 1973, a six-lane section of Highway 101 opened east of downtown, siphoning off traffic from Cochrane to Gilroy. Merchants who depended on the heavy traffic closed down. Others set into motion a plan to revitalize the spirit of a small historic town.

Six

REMEMBERING THE WILDERNESS

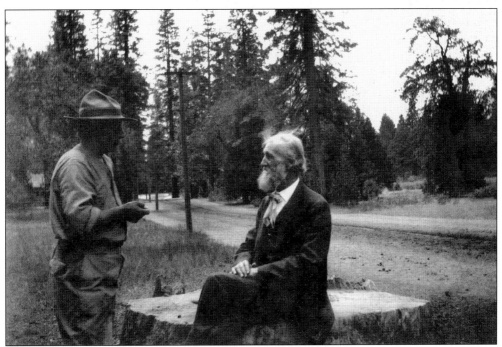

Charles Kellogg, shown at left, was famous around the world as the "Nature Singer." He was attuned to the beauty of our local forests and lived in Morgan Hill for 30 years. He and John Muir, father of the national parks movement, were kindred spirits. On this occasion, Kellogg had hiked 111 miles to meet Muir in Yosemite Valley. This is the last-known photograph of John Muir, who died on December 24, 1914. Each man led national campaigns to save the beauty of the wilderness for future generations.

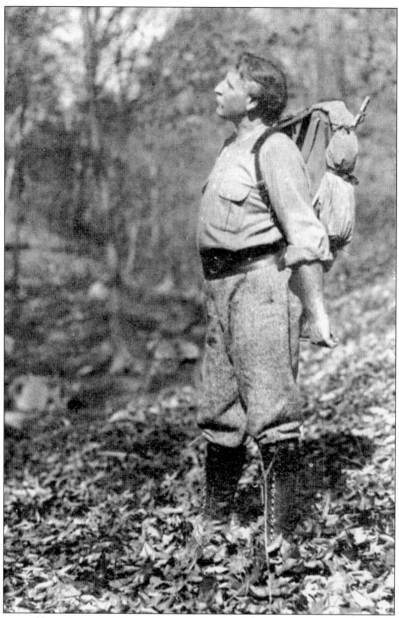

Kellogg was a self-taught naturalist, at home in the woodlands which were also his laboratory. As a boy, free to play alone in the wild forest, he observed that he could make many of the same sounds as the birds and insects around him. He cultivated a love and respect for nature. Later, in his teens, when he began to perform his birdsongs in public, he realized that the range of his voice was unique; not everyone could reproduce authentic birdsong and cricket calls. He first performed at the original Chautauqua in 1890, and then toured the vaudeville circuit, headlining at the Keith-Orpheum. His voice quickly attracted the attention of physicists and music scholars who tested and measured its range. The high "bird" sounds of his voice soared into the inaudible, above 14,000Hz. His human voice was found to be normal, under 4,000Hz. He developed a friendship with the American scientific community that lasted many years. Charles described the world of inaudible sounds and vibrations all around us as "woods radio."

Even without a formal science education, Charles Kellogg presented his findings to the American scientific community. His experiment with the "sensitive flame" was especially popular and showed the effects of sound on fire—the synergy of two forms of physical energy manifesting at different wavelengths. With his voice alone he could extinguish the bright light of a two-foot flame of gas, burning under pressure, and turn it into an invisible Bunsen flame.

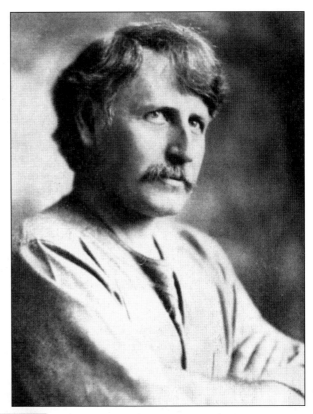

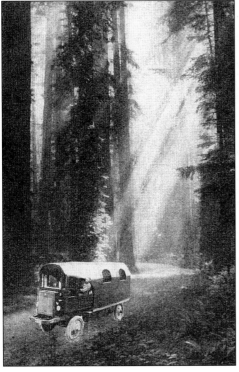

In 1917, he built the world famous Travel Log and toured the United States to sell World War 1 Liberty Bonds. When peace came he resumed his campaign to preserve the groves of great redwoods in California, literally bringing the voice and vision of the forest to those who had never seen a redwood.

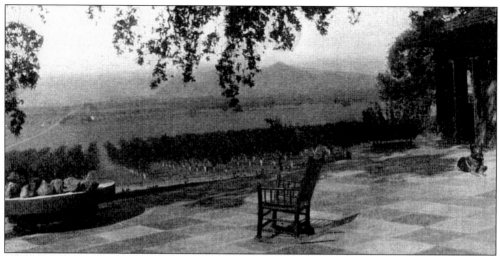

Kellogg believed that his home should not separate him from the elements, but become a place to enclose the view. This early 1900s view of Morgan Hill's fruit orchards is from the terrace of his home on Tennant Avenue. In his memoirs, he says, "A landscape is never as beautiful as when it is seen from the window, the porch, the tent, or even through the barn door; for the homes of men are the center and focus of all nature."

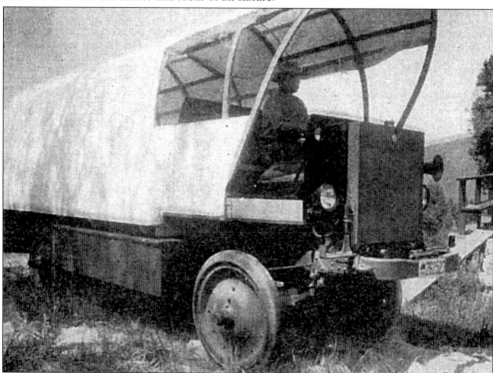

Leaving his ranch in Morgan Hill, Kellogg was prepared to live in the forests of Humboldt County for three months while building his Travel Log. According to his plans, it would take that long to cut the giant redwood log and hollow it out to a shell, so that it would be light enough to haul 300 miles back to Morgan Hill. The Nash Quad shown here was a heavy-duty military truck.

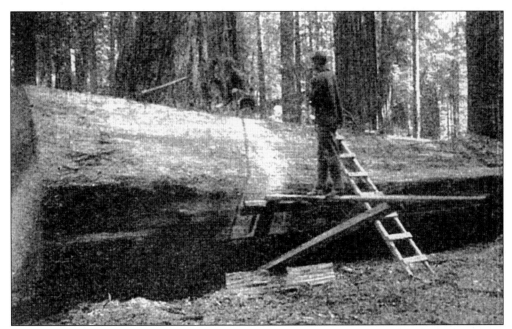

In 1917, the manager of the Pacific Lumber Company gave Kellogg a fallen tree with some $2000 worth of lumber in it, solid to the core. No one could tell how long it had been lying on the forest floor. One old mountaineer recalled cutting through the branches at the top so he could drive his team through, 60 years previously. The first cut took Kellogg an entire day, using a 14-foot, one-man saw. A redwood log 22 feet long weighs roughly 36 tons. Hollowed out and worked down to a four-inch shell, the estimated weight was 11 tons. Kellogg hypothesized that after he had made it into a shell, he could leach out a "ton or two" of sap weight by placing sprinklers inside and out. Then he planed and hand-waxed the interior to show off the grain of the wood and fitted the doors out of a solid piece of burl he'd been saving for years. Shown below at home in Morgan Hill after months of preparation, Kellogg stands ready to start a national tour with the Travel Log.

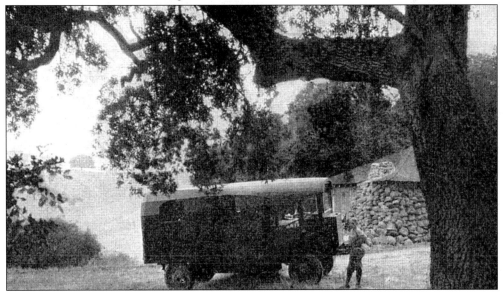

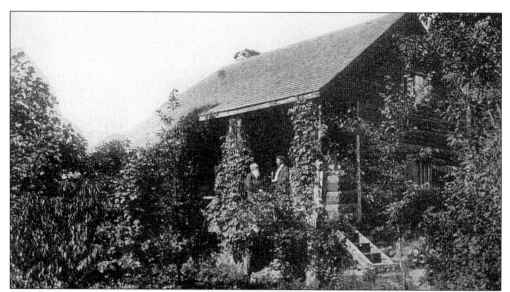

Kellogg was a good friend of the great literary naturalist, John Burroughs, and visited him at his home in West Park, New York. Contrasting John Muir and John Burroughs, both older than he, Kellogg found Burroughs a gentler, more loving naturalist, while Muir was rugged, virile, and fearless. But he stated that it was a privilege to have known both of them. Each in his own way enjoyed the woods and wilderness.

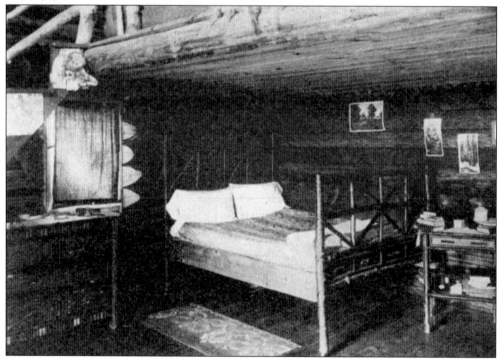

Kellogg made the furniture shown here in the sleeping area of the house he called "The Mushroom" because it seemed to spring up naturally from its surroundings. "I come naturally by my love of craftsmanship—inherited from my dear pioneer father. All his life he was the first man on the job to take the heavy end of the log," writes Kellogg.

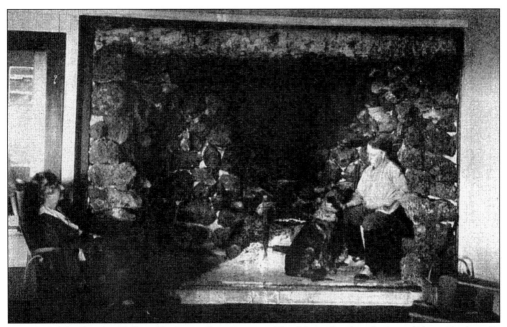

He named his house Kellogg Springs, designing and building the fireplace with his own hands. A trickle of water flows down the sides and across the hearth. On his terrace sat another innovative fireplace, seen earlier, built on wheels to roll it anywhere he pleased. His wife, Sa'di, was a gifted musician and well known in the community. The house is a private residence on Tennant Avenue today.

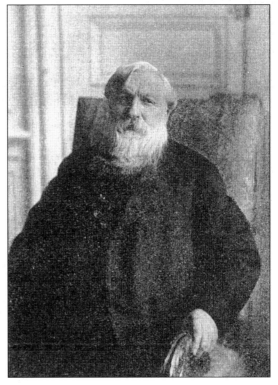

Kellogg often traveled abroad. In Paris, the reclusive sculptor Auguste Rodin invited him to dinner. One evening, Rodin led Kellogg around his studio by candlelight, showing him his statues and works in progress, all the while gesturing to him to sing. Kellogg spoke no French and Rodin spoke little English, but when Kellogg trilled his birdsong Rodin didn't notice the hot wax running down his hand and arm.

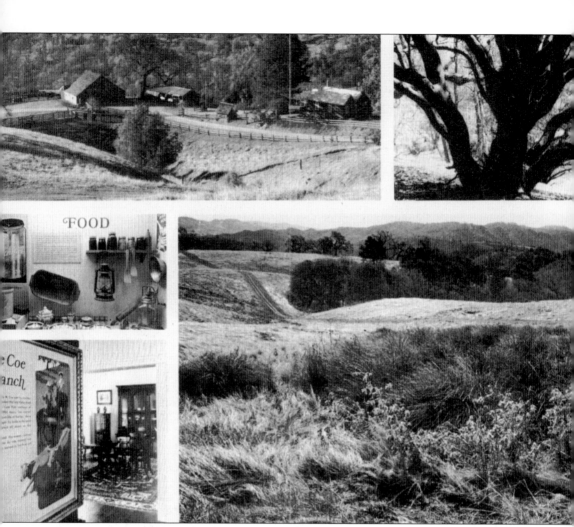

Henry Coe State Park is in the hills at the end of East Dunne Avenue. A 1950s California State Park brochure includes a picture of the old Pine Ridge ranch buildings built by Henry W. Coe Jr. and his brother Charles in 1883. Over the years the Coe brothers bought out their neighbors who gave up trying to farm the hilly terrain. Henry also bought out his brother's interest. He continued to buy land, partly to preserve it and partly to let his cattle roam further afield, operating it as a cattle ranch. His daughter Sada (pronounced Say-da) managed the ranch for him in the 1930s. When he died in the 1940s, Henry Coe owned approximately 12,500 acres.

Sada Coe could be fierce or tender. She rode hard, herding cattle with the best of the cowboys, the brim of her hat flattened back by the wind. And she wrote poetry as well. Shown here is the preface from one of her books, now in the Morgan Hill Museum's collection. After her father's death, she purchased the cattle ranch and managed it for years until she decided to share it with the public as a wilderness park. Gentle ridges, grassy meadows, and ancient oaks invite the mind to expand into timelessness. "May these quiet hills bring peace to the souls of those who are seeking." With these words in 1953 Sada Coe gave away 12,500 acres, her entire beloved Pine Ridge Ranch "to the people" as a living memorial to her father and other hard-working pioneers of the region. (Bottom photo courtesy Anne Rosenzweig.)

Preface

Coe

Silence! And...

The deep deep sky above where stars and the big yellow moon, or the pale clear light of an early dawn and the hushed murmuring of eventide bring the peace and calmness of mightier things, while the small turmoils of life pass away and are as nothing.

The Author—

Sada S. Coe

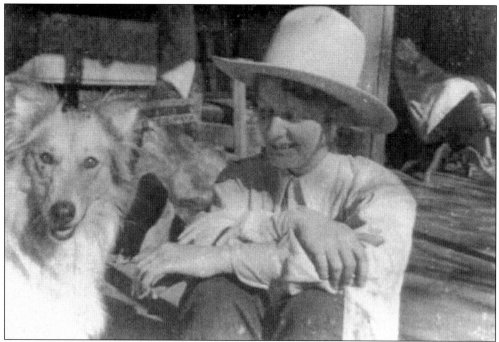

Sada Coe's gift was inspired by her concern for the human spirit. Observing first hand San Jose's transformation into a busting metropolis, Sada wanted to conserve the power of nature to restore and nourish neighbors and visitors. She knew from experience that the undisturbed mountains could provide two valuable gifts—"peace for one's soul and food for the power of thought." Henry W. Coe Park is now 87,000 acres and is northern California's largest state park. It is located at the end of East Dunne, up a corkscrew, curving road into the Diablo Range. (Courtesy Henry Coe State Park Archives.)

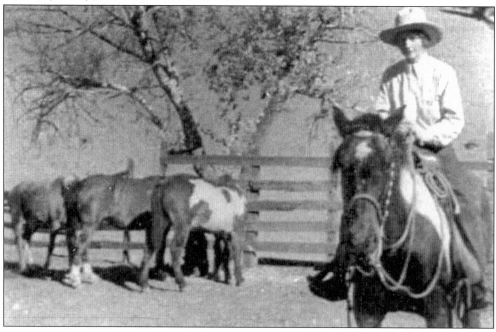

The earliest conservationists are the ones we know the least about. The Indian tribe who inhabited the valley for approximately 3,000 years left it largely unmarked. Their legacy to us includes the forests, clean air, and water, and abundant wildlife. There is no historical record of Indian village sites in the area we now call Morgan Hill. One authentic ancestral Ohlone village site has been preserved at Chitactac-Adams County Park, five miles south of Morgan Hill in the Uvas Creek Valley. The site is known for its prehistoric rock art—circles within circles—and for its abundant mortar rocks, boulders used for grinding acorns into floury meal. The area's oak forest yielded a rich harvest of acorns. Fortunately, all links to tribal culture have not been lost. On this day in 2004, Patrick Oroczo (also known as Yana Hea, One Who Yawns) led his traveling dance group, Amah-Ka-Tura, in ceremonial dances and songs at Chitactac-Adams Park. Oroczo tracks his Indian lineage to 1782, based on Santa Clara Mission records.

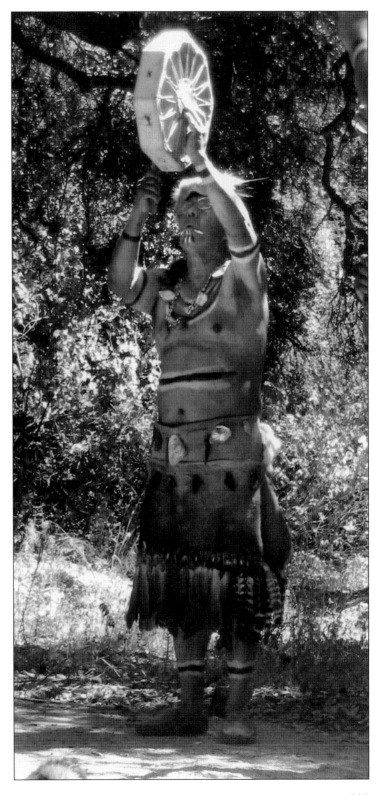

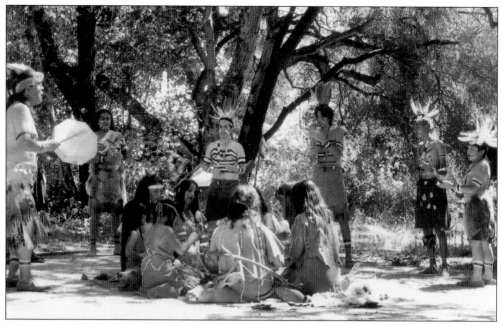

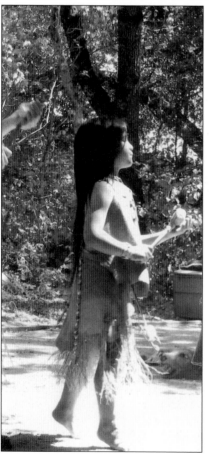

Oroczo, or Yana Hea, says his grandmother, Rose Rios, taught him the first stories and songs, as she remembered them, and he has been teaching them to others. The regalia worn by the dancers is as authentic as he can make it, based on his research and his grandmother's descriptions. On this day, four generations of his family were present at the ceremonies. The group sang songs honoring nature and the spirits of the forest, including the California bear (rarely seen now in this part of the state), the deer, and the coyote.

Seven

FESTIVALS, FOURTHS, AND DOWNTOWN FUN

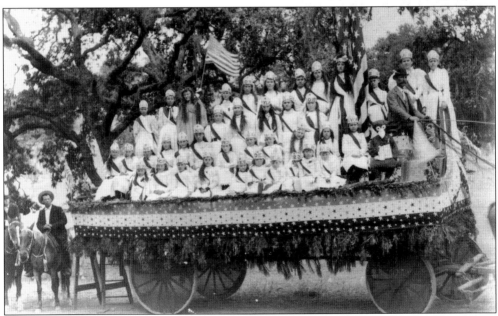

Many hours of preparation must have gone into preparing this float for the Fourth of July c. 1895. Each young lady is wearing a hat named for a state of the union. Among those present were Jennie Edes, Belle Paine, Jennie Bone, Lizzie Tozier, Ethel Weichert, Eva Smith. Ira Paine was the California bear.

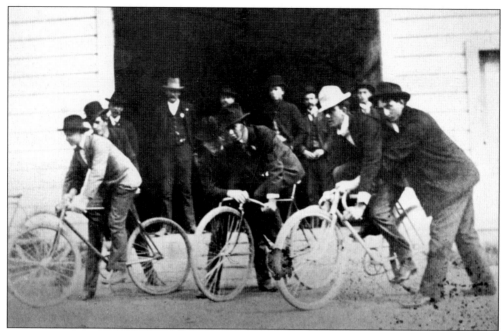

This Fourth of July parade in Morgan Hill is dated c. 1900, before the city was incorporated. The population of the community was fewer than 500. Bicycles were a national craze, a newfound freedom, for work and recreation. Included in this photo were R. Hatch, Frank Bone, J.B. Briscoe, P.B. McGinty, and Lee Johnson, order unknown.

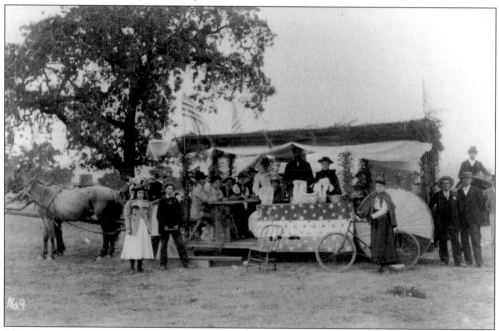

This view of a Fourth of July picnic from the early 1900s is rich in detail. Notice the woman on the right holding her bicycle. By this time, the women of Morgan Hill were also enjoying the liberation of cycling. Dress skirts became shorter for easier pedaling. Susan B. Anthony said that the bicycle was instrumental in the emancipation of women.

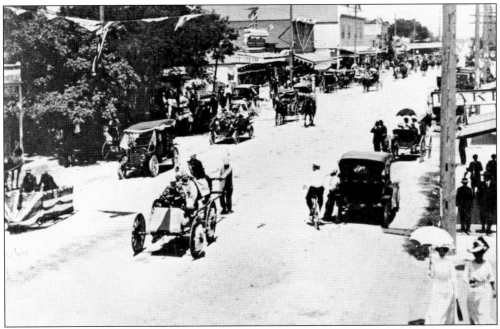

Two captured moments from the Fourth of July parade in 1913 memorialize a bustling and prosperous little city, seven years after incorporation. The community had grown to a population of just over 600. Looking north on Monterey Road from Third Street, the parade trails southward. Gleaming new automobiles mingle with decorated wagons and buggies. It is near the middle of the day and hot enough so that some women have parasols. Luckily, an ice cream vendor is open for business on the west side. A line of cars and buggies is parked along the east side, people watching the parade go by. In the second image, Uncle Sam walks in front of two gaily decorated floats. The sign on the second one says, "We lead others follow."

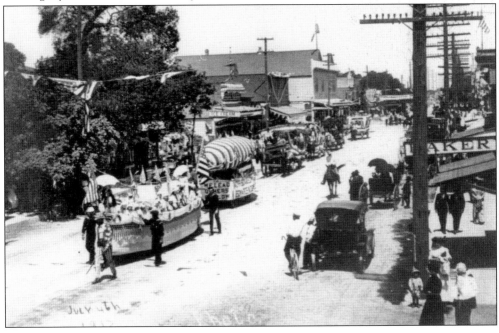

Artist E. Grace Ward worked with oils, watercolors, and pen and ink. The museum's collection includes her watercolor of the old 21 Mile House, the stagecoach stop that used to be on the corner of Edmundson Avenue and Monterey Road. Ward was born in 1877 in Sparta, Wisconsin, and was a member of the Ward family that came to Morgan Hill in 1894. A graduate of Stanford, she taught arts and crafts at the University of the Pacific.

The Friendly Inn was a civic center and community hall, an idea conceived by the enterprising women of Morgan Hill. It was built in 1919 at the northeast corner of Monterey Road and Main Street. This sketch is by artist E. Grace Ward.

Mildred Nagle Speegle has lived in Morgan Hill since 1936. She was inducted into the Santa Clara Softball Hall of Fame and described by one reporter as "a red-headed ball of fire." She says women have always enjoyed playing sports. At school, they would send her to the far side of the field so that she wouldn't break any more windows. Mildred is on the left end of the second row. Her sister Eleanor, the team's mascot, is in the front row, third from the left.

This picture shows the ceremony and order of a Grange meeting in Coyote in the 1940s. The Grange was established as a national fraternal group in 1867 by Minnesota farmer and activist Oliver Kelley, to unite geographically scattered rural farmers to lobby for rural economic development, rural education, and transportation. The farm credit system came about largely due to Grange lobbying that began at a grassroots level.

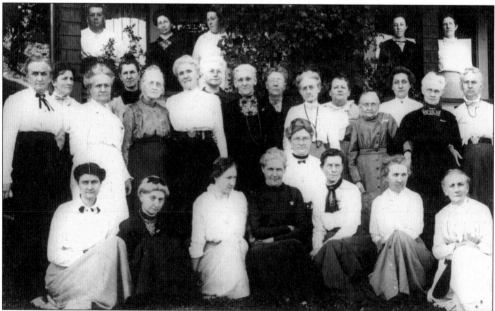

Morgan Hill ladies concerned about problems related to alcohol gathered in support of total abstinence, c. 1916, under the banner of the Women's Christian Temperance Union, Morgan Hill chapter. The national organization was founded in 1874. Included in this photo in unknown order are Alta Guss, Mrs. Acton, Mrs. Weller, Mrs. Flewelling, Mrs. Lane, Mrs. Kimble, Mrs. Hatch, Mrs. Bearce, Grandma Ward, Grandma Walrath, Mrs. Payne, Mrs. Burnett, Mrs. Bagwill, Mrs. Cochrane, Mrs. Purcell, Mrs. Kemp, Mrs. Huggett, Mrs. Earls, Grandma Lovejoy, Mrs. Edwards, Miss Flora Earls, Mrs. McCreary, Hattie Marken, Mrs. Arnold, Mrs. Lynch, Mrs. Hensel, and Mrs. Porter.

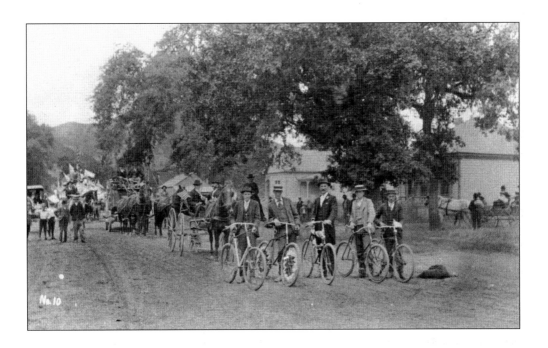

Above, cyclists lead the Fourth of July parade, c. 1900. In July 1926, the talk of the town was the visit of His Royal Highness the Crown Prince and Her Royal Highness the Crown Princess of Sweden. Morgan Hill residents dressed in Sunday finery and waited for the royal couple's arrival. The prince and princess planned a brief stop in Morgan Hill on their way to Sveadal, a resort community west of town.

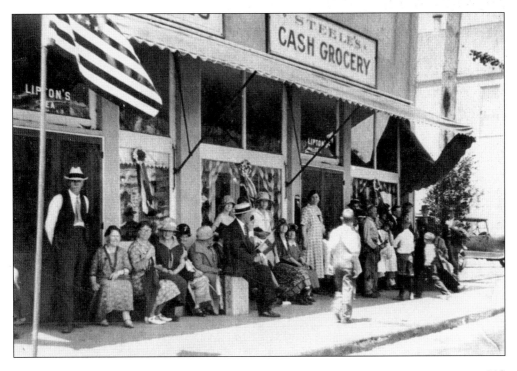

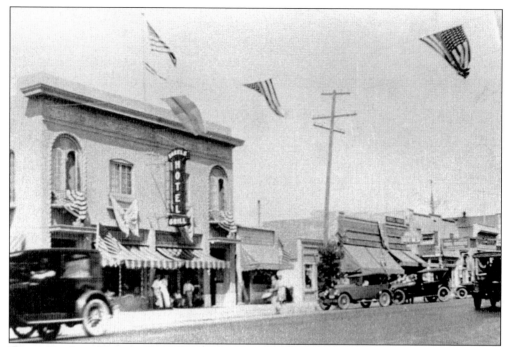

Henry Skeels and his son Harry built a hotel in time for the royal visit. The hotel featured a restaurant and bar and later served as the depot for the Pickwick Stage in 1929, and the Greyhound Bus line from 1937 to 1946. On the day of the royal visit, the balconies, which had been specially designed for the visit, were festooned with flags and ribbon.

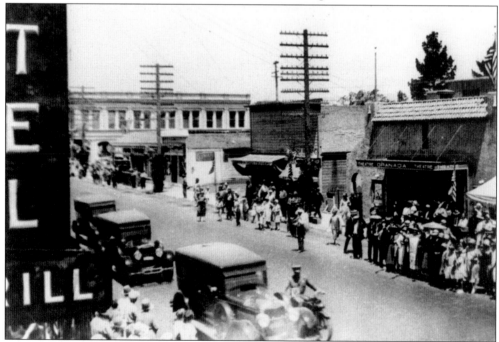

As the royal party began to arrive, someone leaned out over the hotel balcony and took this photograph.

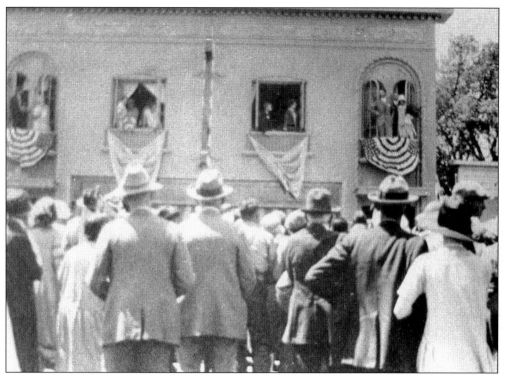

Finally, the moment everyone had been waiting for—a chance to stand and cheer as the royal couple appeared on the far right balcony. The mayor of Morgan Hill was Clyde Edes, and his daughter Norma presented the royal couple the fruit of local labor, a basket of prunes.

The history of the Skeels Hotel and downtown are intertwined in another way. To widen Monterey Road the buildings on the west side were dragged 17 feet further back. Unfortunately, the hotel had been built with a concrete foundation and it could not be moved. The front of the building had to be blasted off with dynamite to accommodate the wider road. Many of its architectural details were lost, including the balconies.

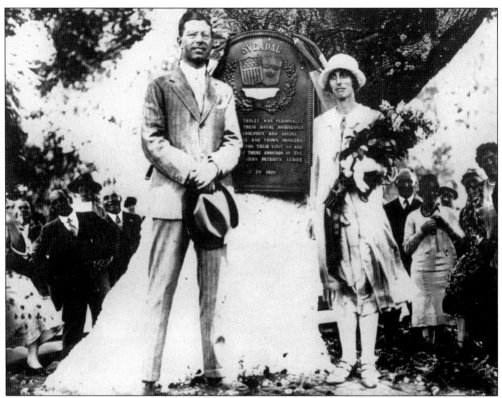

In 1926, the Swedish American Patriotic League purchased 110 acres and created a resort for Swedish cultural gatherings in the Uvas Valley, off Croy Road. The Swedish Crown Prince, Gustav Adolph, and his wife visited the resort and dedicated a plaque to the league. The resort was named Sveadal, which translates roughly as Swedish Valley.

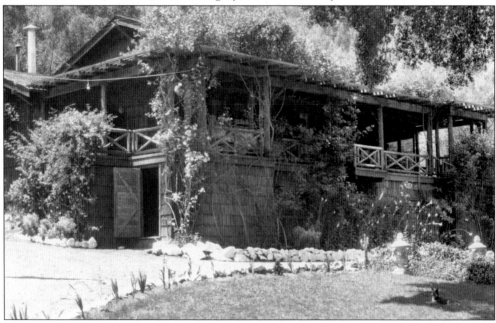

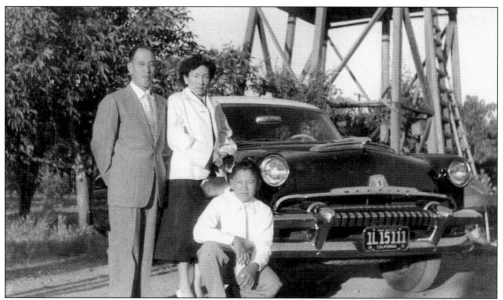

A1954 Mercury was a thing of beauty, and to own one was the dream of many an American. Phillip Kobashi, born in 1904, in Wakayama, Japan, lived in Southern California, working on farms. In 1942, following Pearl Harbor, he and his family, like many American Japanese, were evacuated from their homes to Arizona. Released after three years at the camp, the family settled in San Martin, where Phillip bought a 15-acre ranch and eventually achieved his dreams.

The 1950s brought style and glamour to some in Morgan Hill. On this occasion, Miss Morgan Hill needed to make a grand entrance at the fairgrounds in San Jose, about 15 miles away. She arrived by plane. Doug Downer was the pilot and Bob Johnson from the chamber of commerce greeted the beauty, whose name was Barbara Dollace The aircraft was a Piper Supercruiser PA-12, which landed on a stretch of track.

The Flying Lady was a restaurant that doubled as a museum. Owner Irv Perch named it for his wife, Jan, a licensed pilot. The couple moved to Morgan Hill in 1958 and first founded a successful trailer business called Aristocrat Travel Trailer. In 1969, they sold Aristocrat and began their next project, the restaurant, museum, and parklands called "Hill Country." Among other things, Irv collected unusual antique aircraft. The pride of his collection was a 1929 Ford Tri-motor, the first commercial passenger aircraft to make transcontinental flights from New York to Los Angeles. According to one source the coast-to-coast flight took 48 hours. Flying was only done in the daylight and passengers made half of their journey by train at night, then back on the plane the next morning. Perhaps the plane took the night train too.

In 1979, the community united and created a unique event destined to become a Morgan Hill tradition, the Mushroom Mardi Gras, named for one of Morgan Hill's most abundant commodities. The first Mushroom Mardi Gras began as a fundraiser to purchase much-needed equipment for the community's fire department. Fire Chief Brad Spencer proposed the idea of a harvest festival in 1979 as a way of raising funds while celebrating the community's agricultural roots. (Courtesy Tilly Mayeda.)

Morgan Hill

Mushroom Mardi Gras
1980

October 18th & 19th
10:00 A.M. to 5:00 P.M.

HILL COUNTRY
15060 FOOTHILL ROAD, MORGAN HILL, CALIFORNIA

FEATURING AGRICULTURE PRODUCTS OF THE AREA — MUSHROOMS — 80 DIFFERENT MUSHROOM DISHES
MUSHROOM DISH CONTEST — KIWI — STRAWBERRIES — HONEY — FOOD BOOTHS — FARMERS MARKET
WINE TASTING & APPLE JUICE TASTING — ENTERTAINMENT — GAME BOOTHS — MIMES — CLOWNS — PUPPETS
CHILDRENS AREAS — BABYSITTING FACILITIES — ART SHOW — CIVIL WAR ENCAMPMENT — HOT AIR BALLOONS
SKY DIVERS — MOTORIZED HANG GLIDER DEMONSTRATION — INDIAN TRIBES PERFORMING CEREMONIAL DANCES
PLUS THE KINGSTON TRIO

Sponsored by Morgan Hill Fire Department Equipment Procurement Department Co-Sponsored by Morgan Hill Chamber of Commerce

GENERAL ADMISSION $3.25 CHILDREN UNDER 12 AND SENIOR CITIZENS $1.00

The first Mushroom Mardi Gras, shown here in 1980, was organized by volunteers. This tradition has continued. The date was changed from a harvest festival to Memorial Day weekend, for better weather. Brad Spencer, the bright spark who ignited the fun and feasting, has served on the board of directors every year for the past 25 years. The Mardi Gras provides fun while supporting college-bound seniors. (Courtesy Tilly Mayeda.)

125

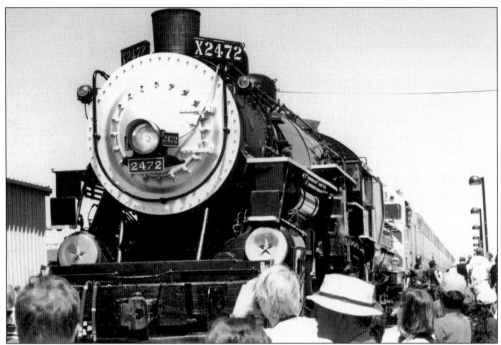

A special train from San Francisco to Morgan Hill was arranged just for the Mushroom Mardi Gras. Charter buses fill up to take visitors to the event. Attendance averages 20,000 people a day, thanks to the top musical groups, craft stalls, artists, food, and drink. Due to national media attention and community support, the Mardi Gras has raised more than $500,000 in college scholarships. (Courtesy Tilly Mayeda.)

A dusting of snow in January 1989 transformed Monterey Road into a frosted greeting card, in keeping with the spirit of the holidays. (Photograph by Robert Buchner; courtesy Morgan Hill Historical Museum Collection.)

What could be better than this moment in the history of downtown Morgan Hill? May we all remember our own special moments in days past with equal wonder and delight. (Photograph by Robert Buchner; courtesy Morgan Hill Historical Museum Collection.)

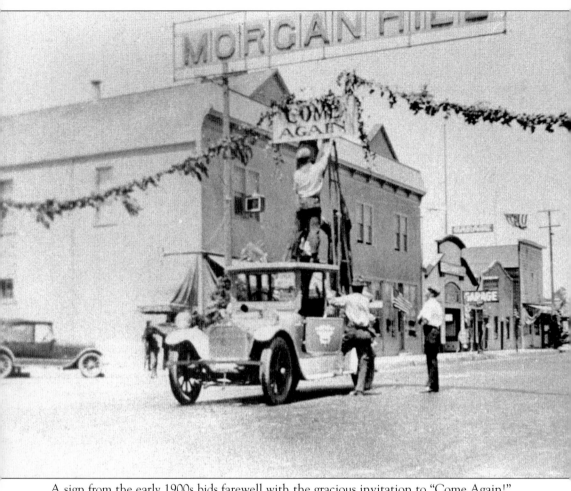

A sign from the early 1900s bids farewell with the gracious invitation to "Come Again!"